DOT DRAWING

A FUSION OF STIPPLING AND ORNAMENT

DOT DRAWING

A FUSION OF STIPPLING AND ORNAMENT

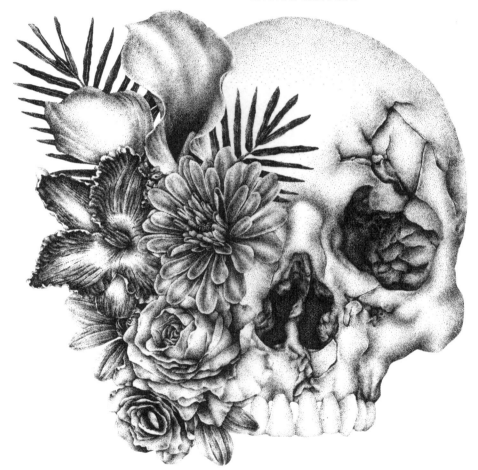

Spider.Money

SCHIFFER
PUBLISHING

4880 Lower Valley Road • Atglen, PA 19310

© 2019 Schiffer Publishing, Ltd.

Text and images copyright © 2019 Spider.Money

Packaged by BlueRed Press Ltd. 2019

Library of Congress Control Number: 2019936867

Designed by Insight Design Concepts Ltd.

Type set in Neutra Text

ISBN: 978-0-7643-5853-1

Printed in China

Published by Schiffer Publishing, Ltd.

4880 Lower Valley Road

Atglen, PA 19310

Phone: (610) 593-1777; Fax: (610) 593-2002

E-mail: Info@schifferbooks.com

Web: www.schifferbooks.com

For our complete selection of fine books on this and related subjects, please visit our website at www.schifferbooks.com. You may also write for a free catalog.

Schiffer Publishing's titles are available at special discounts for bulk purchases for sales promotions or premiums. Special editions, including personalized covers, corporate imprints, and excerpts, can be created in large quantities for special needs. For more information, contact the publisher.

We are always looking for people to write books on new and related subjects. If you have an idea for a book, please contact us at proposals@schifferbooks.com.

CONTENTS

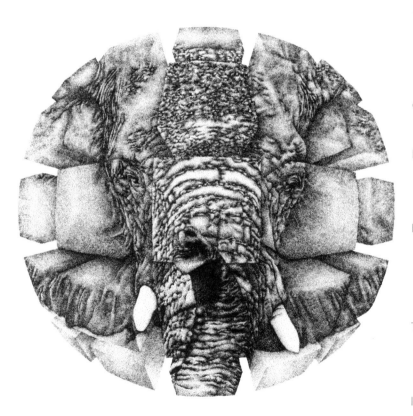

"BARBED ROSES"

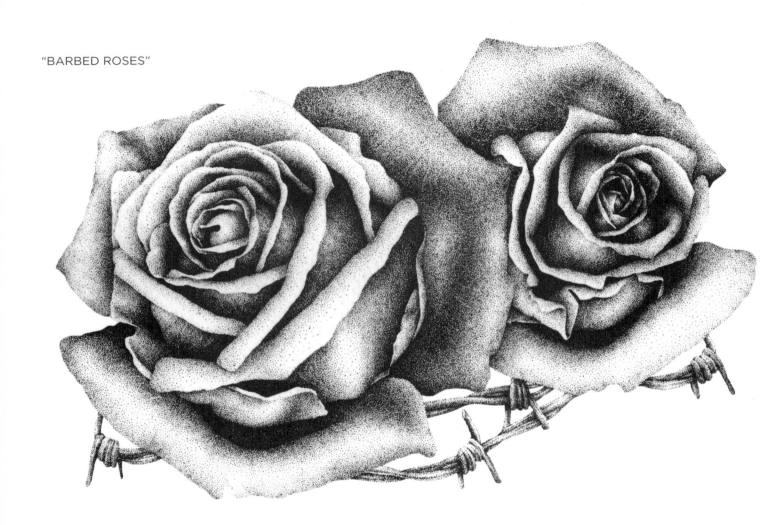

INTRODUCTION

Dot drawing is simply and entirely about details—how a few smalls dots can create something altogether much greater. Thanks to the ever-increasing popularity of tattooing, dot drawing has become a distinctive style, familiar to everyone in the worlds of modern art and popular culture.

Also known as "stippling," dot drawing is categorized alongside pointillism as a particular drawing and painting technique where the artwork consists of patterns made up from thousands of deliberately planned and placed dots that imitate perfect shape, form, and depth. The simplistic name "dot drawing" makes it sound easy—however, stippling requires deep understanding of the balance between positive and negative space.

A single dot added to negative (empty) space leads to the reduction of the value of brightness in that area. Furthermore, a group of dots gathered together in one area produce more positive (filled) space, in the forms of darker tones and shadows. Additionally, patience is a crucial aspect in creating dot-drawing art. This is because stippling is a very time-consuming process that often demands attention to every minuscule detail—but all this hard work definitely pays off in the end.

I personally find dot drawing especially interesting when it is associated with line patterns, such as medieval English ornament. This combines two distinctive styles—realism and abstract—my two original artistic preoccupations. Stippling indulges my affection for realistic drawing, while abstract works reflect my interest in unique forms and monochrome tones. The stories I like to tell through my pieces are mostly inspired from the center ground between the two—such as the contrast between life and the afterlife, construction and annihilation, and so on. I like to bring two opposites together and blend them into one piece of paper, and hope everyone can see and get lost in the details, as I find I often do.

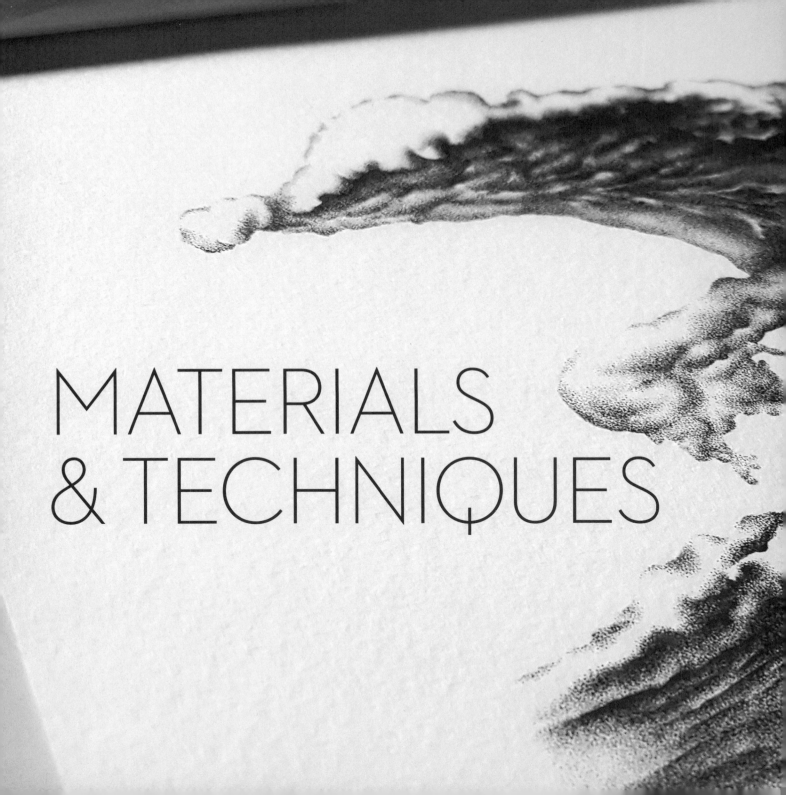

MATERIALS
& TECHNIQUES

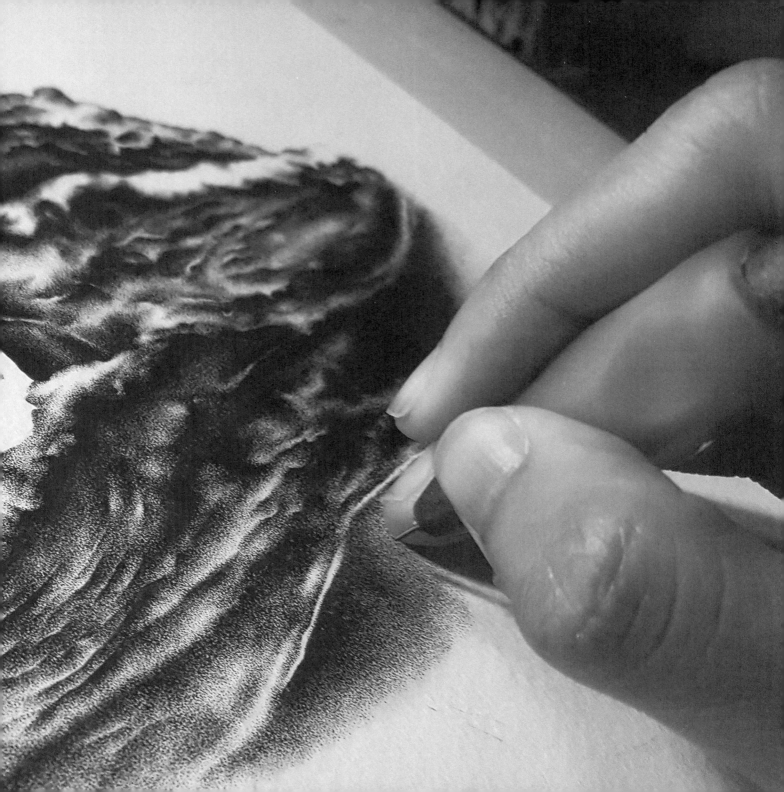

MATERIALS & TECHNIQUES

.10 is used on highly detailed areas

.20 is for regular use

Isograph ink refill cartridge

There are only a few things you need to start dot drawing—some good paper and drawing instruments that are sharp enough to create fine dots and clean lines in precise, small, detail. The instruments you use are entirely personal; there is no right or wrong: use whichever instruments suit you.

First and most importantly, pens. There are two types to choose between, refillable and nonrefillable pens. The latter, such as fine-liners, form a consistently even dot size and are slightly easier tools to use. Even though they are not refillable, they are reliable and the ink will not bleed onto the page. Moreover, there are a huge variety of brands, sizes, and price ranges to choose from. My favorite nonrefillable pen is Pigma micron from Sakura; these contain micropigment ink that is waterproof, durable, and available in many stationery stores. My only recommendation for this type of pen is to choose a small-width size, 005, 01, and 02.

The alternative option is a refillable pen: these are more technical and consequently often used by professional artists. One of the best I've found is an Isograph pen from a German brand called Rotring. Their products are well known in the stippling community because the pens are robust, stipple beautifully, and are refillable in a variety of ink colors. For very sharp dots, use nibs as fine as .01 or .02, while for bigger pictures, larger nib sizes like 0.3 and 0.5 are very helpful since the dots fill the space much more satisfactorily. Refillable pens are quite expensive compared to nonrefillable ones, although they last much longer. Their nibs are quite fragile, but fortunately, you can buy nibs separately.

Whichever type of pen you choose, they both will provide you with the same result: dot-drawing pieces that are crisp, clean, consistent, and perfect.

The paper you use is just as crucial as your pens. I think that the quality of the paper is more important than the brand. So, always choose fine-art papers weighing 200–300 grams. This thickness absolutely prevents ink bleed. Rough surface paper also gives you an excellent textural base for your artwork.

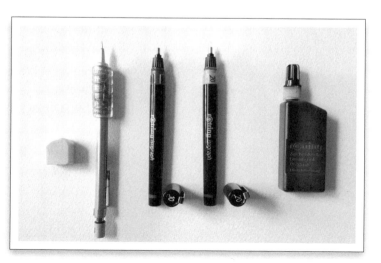

TECHNIQUES

Dot drawing (or stippling) consists solely of countless dots—it is for the viewer's imagination to complete the picture.

The numbers and pattern of dots are made so as to produce shading, which for depth perception is achieved with various levels of darkness (i.e., density of dots). This technique was discovered sometime around the 1500s, when it was often used in illustrations for publication, mainly for cost-saving purposes.

Look at the diagrams below: note how the density of the dots and space between them determine the level of darkness. These different opacity levels are used for shading in drawings and illustrations. The highest level of darkness is called "shadow area," while the lowest level is referred to as the "bright area."

Different distances between the dots create different levels of density.

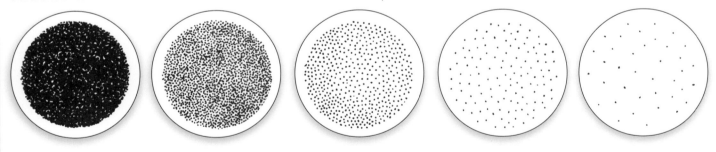

When you put the levels together, you can clearly see how shading works with stippling.

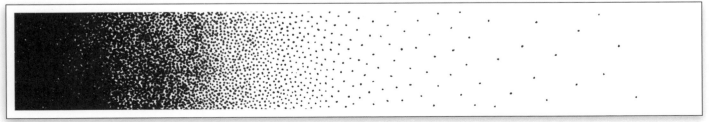

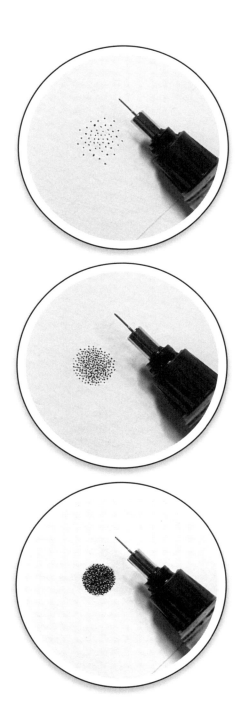

In addition to levels of dot density, the sizes of pen nibs have a visible effect as well. The commonest variety of widths used for dot drawing are 0.01, 0.02, 0.3, and 0.5 millimeters*; the smallest is 0.01, while the largest is 0.5.

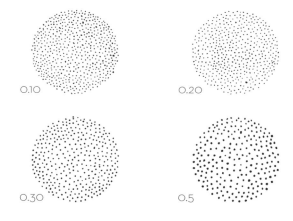

0.10

0.20

0.30

0.5

*These are specifically nib sizes for Isograph pens.

Dot drawing is a technique that requires consistency, not just randomly placed single dots. Know your tools and be comfortable with them. Also, constantly practice to achieve perfect skill.

DOT DRAWING DOS AND DON'TS

DO

1. Find your own rhythm by, for example, listening to your favorite songs. Perhaps practice dotting by following the beats, which might help you get more confident.

2. It is important to sketch first. Begin with a rough but light sketch of underlying linework for your design.

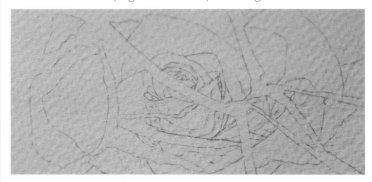

3. Before you start dot drawing, study the play of light and shadow across the object that you want to draw, then mark each light and dark area with pencil.

4. Starting with the darkest area first makes it easier for you to control the numbers of dots in the lighter areas.

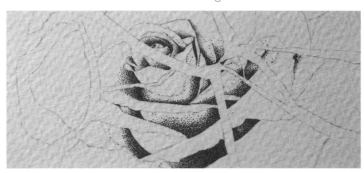

5. Remember that the lighter areas require fewer dots than the dark areas.

6. Work on just a small section at a time. That way you are more in control and won't feel too overwhelmed.

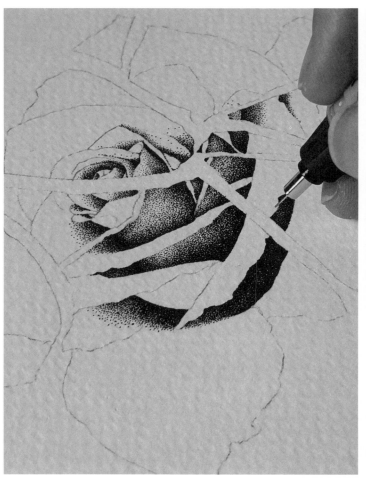

DON'T

1. Avoid creating unintentional dashes when dotting too fast without lifting your hand. Remind yourself to lift up your pen, and slow down a bit when you are going too fast.

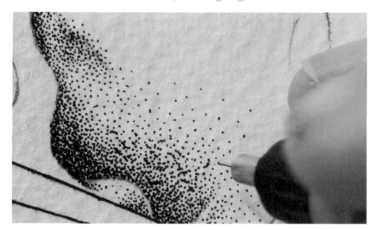

2. Don't pay too much attention to one area and completely forget the rest. It is easy to get lost in one small section, and all of a sudden you are overworking it. Always lift your pen up to get consistently perfect dot shapes. Often step back and stop to look at the overall composition of your artwork.

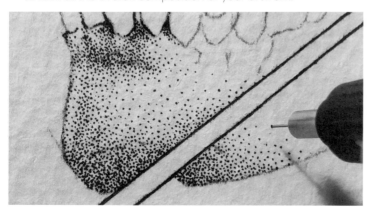

3. Do not rush. Stippling requires a lot of time: clear your mind and you will be fine.

4. Don't hold your pen too tightly; it will be impossible for you to control the thickness of the dots.

5. Don't press the nib too hard onto paper, and do not hold it there for too long.

6. Don't push yourself too hard, if your eyes are getting tired, go and have a rest or leave it for another time.

FORM AND PRACTICE

Dot drawing is not an easy technique for some people to master; it takes good, regular practice to accomplish realistic accuracy.

The best way to start is to practice drawing a simple object with a smooth surface, such as a cone, cube, or sphere.

CONE

Think of a cone as a triangle with one side; it doesn't make it easier than a triangle, though it is more fun to practice. Place a white cone on a table, balanced at the same height as your eye level, then shine a light from a table lamp onto one side of it to give distinct highlights and shadows.

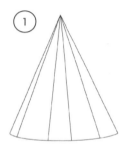

Draw a rough sketch of a triangle. Mark a section of shadowed area and a highlighted area.

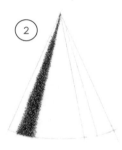

Start stippling on the darkest part of the cone. Place dots as close together as possible, as many as the space allows.

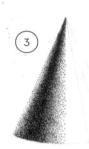

Next, gradually spread the dots farther around the dark area, but not quite as densely. Keep the highlighted section blank.

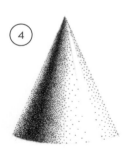

The first time you do this, it will be difficult to assess the correct number of dots to place. So, put the dots farther apart to cover all the space.

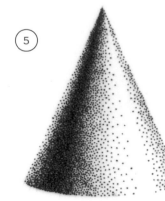

After this, carefully and slowly, add more individual dots over the area where more shading is required. Graduate the shading, keeping the volume of the cone in mind.

CONE TEMPLATES

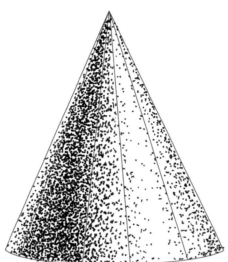

Use these templates as
guidelines to practice shading.
Try moving the highlighted
area into different positions.

CUBE

Before starting to draw, study the object for its texture, shape, and color. A cube is a good practice object. It has six sides in total, but only three sides are visible at once. Place it on a table and turn it 45 degrees to be equally symmetrical between a left and a right side. Set up a light to hit the left side of the cube in such a way as to give differing light and shade on the three planes. Now you're ready to start.

Draw the cube outline on paper. Notice the side where the blackest shadow lies (in this case, the right side), then put a plus sign there. To mark the brightest spot or highlight, put a minus sign on it. The rest is gray area: draw outline patches where different levels of the midtone fall. Notice that closest to the highlight it has a lower gray level than a spot nearer to the light.

Start with the core shadow (darkest) side first; fill this side with as many dots as you want until this side is completely black.

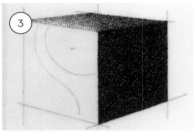

The top side has a darker midtone than the left side, but it is not as dark as the right plane. Stipple to cover all its available space, but not as densely as the deep shadow side.

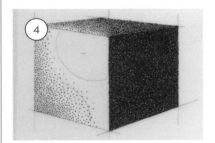

For the lightest side, gingerly place dots on the outer area, but remember to leave the highlight area clear for now. The space between the dots on this side needs to be farther apart than elsewhere.

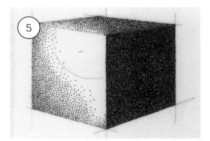

Go back and repeat the dots to give the cube more volume as you feel necessary.

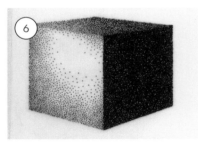

For the highlight area, spread the dots apart across the space. This should give a gray tone: the farther apart, the lighter the tone. Add slightly fewer dots to the edge of the top right corner to soften its sharpness.

CUBE TEMPLATES

Use these templates as guidelines to practice shading. Try altering the levels of shading density to see which is most effective.

PYRAMID

A pyramid is simpler to draw than a cube since it has only two visible sides. This example is set up at an angle of between 20 and 35 degrees, to give a perspective that is not too deep or too shallow.

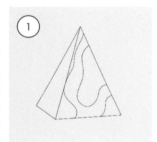

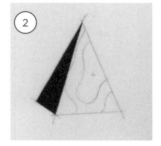

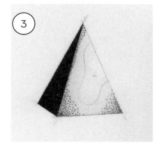

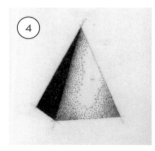

Sketch a simple outline of two triangles connected at the pointy tops. Mark a plus symbol on the core (darkest) shadow side. Delineate the brightest area on the right, then mark it with a minus sign. The rest is midtone gray; separate this area into two levels, split between the darker midtone level that covers a low ground section, and the midtone level on the center next to the highlighted area.

Remember to begin at the darkest part of the object. Start dot drawing on the core shadow side (on the left) and keep this side denser than the other parts where the light can't reach.

Start around the corners on the main face, lightly covering all three corners with dots.

Move to the darker midtone area, but place these dots farther apart.

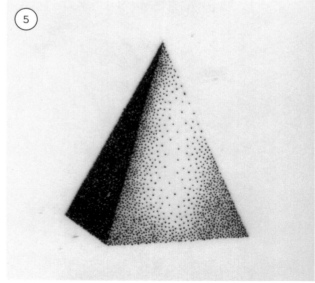

Finish by adding a few dots inside the highlight area. Start around the inner edge and place a single dot at a time, but keep the middle as clear as possible to show the brightest area caused by the light.

PYRAMID TEMPLATES

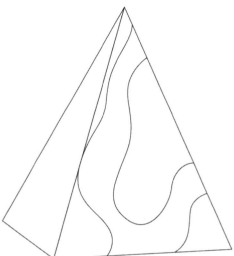

Use these templates as guidelines to practice shading. Try altering the levels of shading density to see which is most effective.

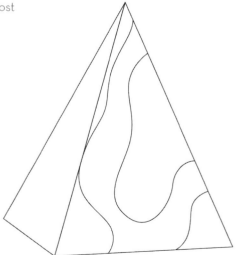

SPHERE

Perhaps a sphere is the hardest object to draw out of all of these volumes, even though it has just one side and no corners. It is difficult to achieve a perfect gradient with dots. However, start by working on one small area at a time.

Outline a simple circle. Notice that the light comes from the right side, which means the left is absent of light completely. As always, mark out the highlighted area, then divide the gray midtones into two levels.

Fill the extreme left area with dots as dense and closely spaced as possible.

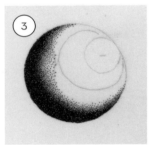

The next section is for midshading, to a level between the core shadow and midtone gray.

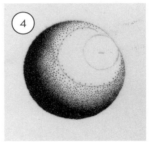

Gradually cover the darker of the midtone areas, using fewer dots than in the previous section.

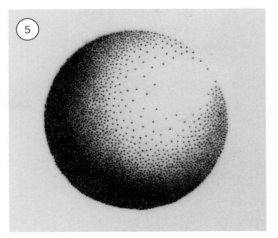

For the second midtone section closest to the brightest area, place fewer, lighter dots. Focus on the length of space between the dots as well as the numbers of dots: further and lesser dots mean this area will be brighter. Remember to keep the highlighted area absolutely clear of dots.

SPHERE TEMPLATES

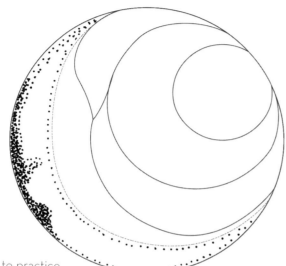

Use these templates to practice your dot technique. This shape requires more subtlety of shading to look realistic.

ORNAMENT

Ornament is an important feature in architecture and the decorative arts. Every culture has created its own distinctive style, while similarly, each era developed its own individual look. Consequently, there are an enormous variety of motif designs. Perhaps the heyday of the motif in Europe was between the sixteenth and eighteenth centuries, during the baroque and rococo periods. Both styles are characterized by exaggerated lines and complicated details, elaborate curves, and plant-shaped ornamentation.

Modern ornamentation tends to be much simpler and deliberately bare of overly detailed design.

This exercise shows a letter **P** filled with leaf details. Draw the outline of the letter **P** and sketch in the outline of a leaf. Then break this down further into multiple smaller leaves. The entire letterform should be filled with curved lines.

LEAF ORNAMENT

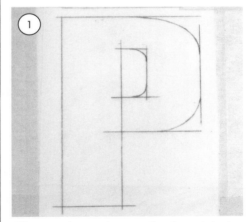

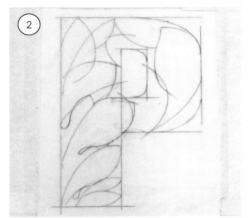

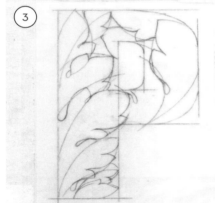

Choose a letter shape with a large interior that provides plenty of scope for detail, in this example a **P**.

Draft a rough outline of leaves, playing with the curves of the letterform. A simple trick to create a coherent design is to give all the elements the same directional flow.

Polish the rough details and break the design down into smaller pointy ends of two or three small leaves. At no stage should you work outside the letter profile.

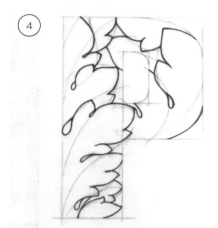

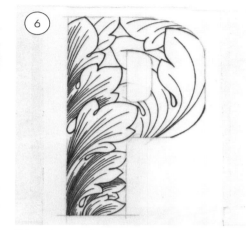

When you're happy with the composition, ink over the outlines with a fine liner or a 0.5-nib pen. Do not outline the letter.

Draw the main veins of each leaf. These lines provide the structure of the pattern and must follow the shape and direction of the leaf as they would in nature.

Fill in the smaller side leaves. Remember that the front row should be brighter than the back row, so use fewer inner lines.

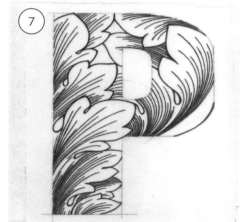

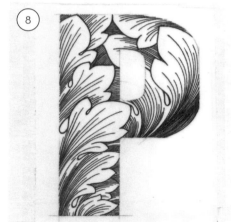

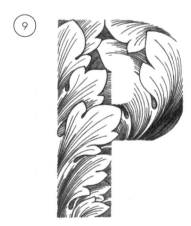

Move to the other side. The distance between the lines affects shade as well. The darker tones at the leaf base are the result of denser lines.

You can go back to fill in a space where needed, but keep all the lines inside the letter.

Draw small sets of line patterns in the gaps between the leaves; alternatively fill the gaps in with black ink.

ORNAMENT DOS AND DON'TS

Ornaments are specifically designed to adorn a surface—be it a building, a book, a piece of furniture, or so on. It is usually a bespoke piece, detailed and sized to complement its setting. It can be as elaborate or simple as you like, but what it does need is considered thought and design so that it suits its purpose. An ornament should enhance its setting, not overwhelm it or be so insignificant that it is completely overlooked.

DO

1. Study baroque and rococo arts. Both styles are all about curves, and their ornamental patterns are noted for their elegant, feminine forms. Go with the flow by loosening your pen grip a little so you can draw elegant flowing curves.

2. Play with the shape of letters or objects that work as a distinct outline. Here the ornaments inside the letter G look more natural with arched leaves. Let the shape of the object influence the direction and flow of the ornamentation.

3. Here the different thicknesses of the leaf outline make the design stand out more. As ever, practice makes perfect, so start with a single leaf and progress across the design as you feel more comfortable and confident.

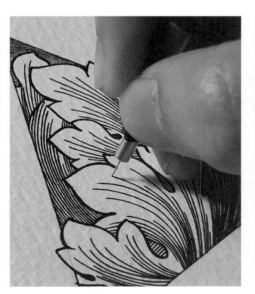
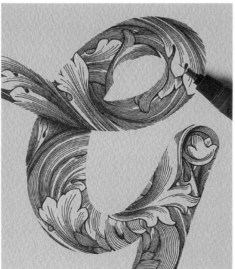
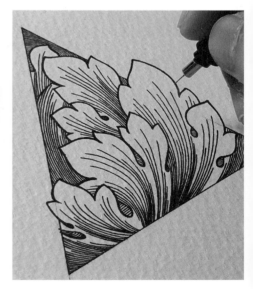

DON'T

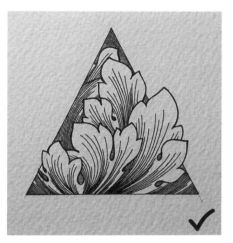

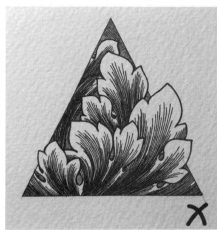

1. Do not overly flood the design with too many and too-dense lines. Leave enough space for the design to breathe.

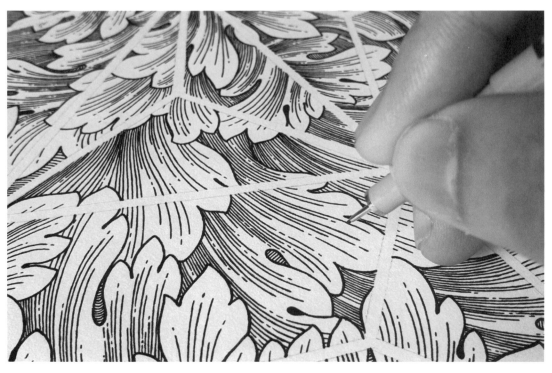

2. Having said all this, don't be afraid to express your own creativity. Try drawing each line differently, or twist some lines, and vary their lengths. Above all, do not get stressed about it—this is supposed to be fun! When you are a beginner, remember to rest your hand between practice sessions for five or ten minutes.

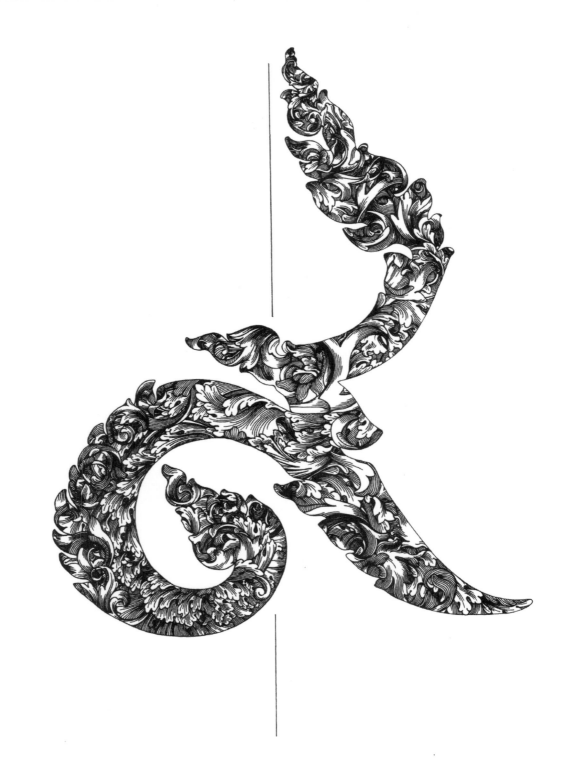

LETTERING

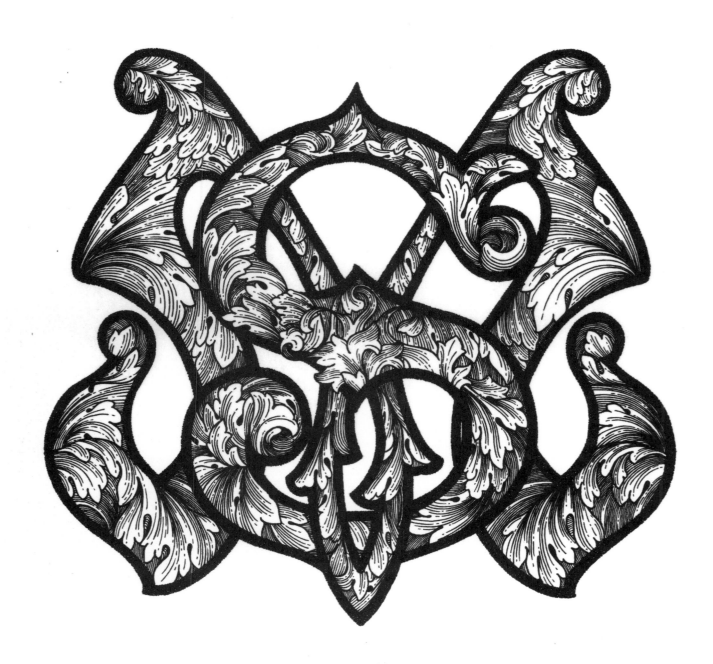

MONOGRAM

Baroque and rococo styles are characterized by highly elaborate ornament that combines scrolling curves and theatrical leaves to intensify motion and dramatic volume. Baroque thrived throughout the seventeenth century, while rococo started in France and Italy in the 1730s and rapidly spread in popularity across the rest of central Europe. I love studying its unique style and feel inspired by its intricate designs and elaborate detailing.

I began to search for my own artistic style right at the beginning of my career, when I first learned about rococo and baroque in an art history class back in my university days. I was caught by its exuberant style and exaggerated detail. Since then I have often incorporated these elements into my works, alongside Old English ornaments, and my own signature contrasts black and white style. I consider the result to be a perfect mixture between the new and the old—a unique style that I want to present to the current art world, where the old ways of doing things are almost completely forgotten. I believe monograms will soon be widely appreciated and desired for commercial logos.

Most monograms are basically initial letters (of people or companies) that are assembled together—overlapping and interlocked—into a single design. Monogram lettering works well with ornamental elements. The style decorates the interior of composed letters to make them more exquisitely decorative design.

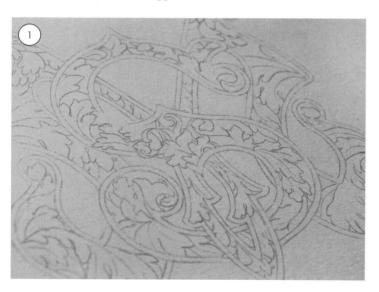

Plan and sketch out a monogram, using pencil. The letters must be large enough to leave plenty of empty internal space for rococo leaves and flourishes.

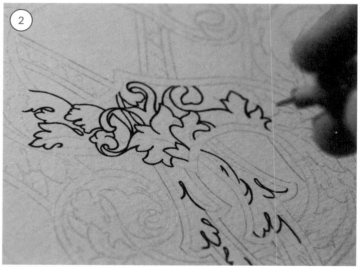

When you're happy with the composition, ink in the outlined pattern, using a fine-tipped pen.

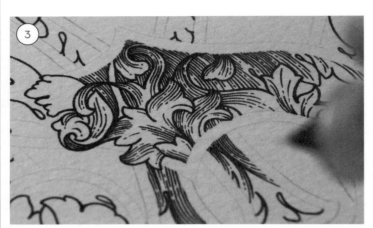

Following the direction of the curling leaves, gently furnish each leaf with multiple cursive lines.

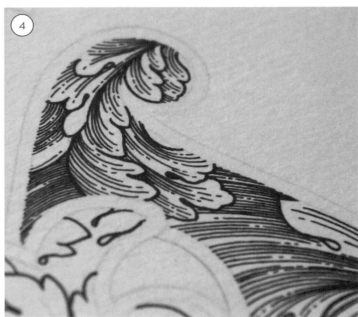

For variety, draw lines of different lengths. And don't use just single lines—chop them up a little into two, three, or more bits.

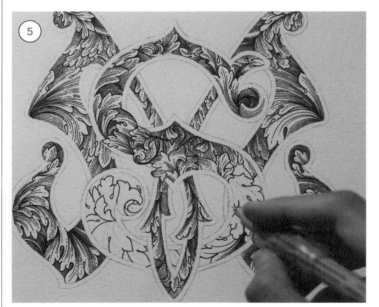

Carefully fill all the blank interiors. Freehand drawing lines should be like flowing water in a river; do not rush this process.

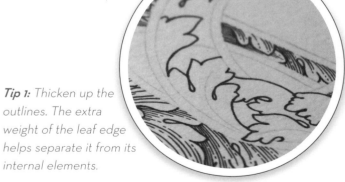

Tip 1: Thicken up the outlines. The extra weight of the leaf edge helps separate it from its internal elements.

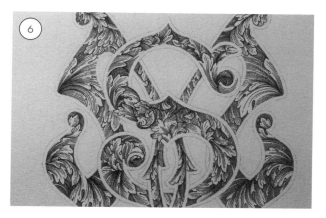

Now the interior is completed. Recheck it, adjusting the details as necessary.

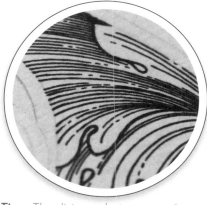

Tip 2: The distance between each line provides a depth and shadow effect similar to shading.

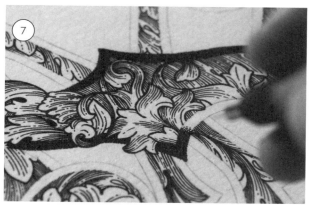

The simplest step is next— fill the blank border, using a stippling technique. Use an 0.2 Isograph pen or a bigger-tipped pen.

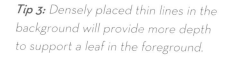

Tip 3: Densely placed thin lines in the background will provide more depth to support a leaf in the foreground.

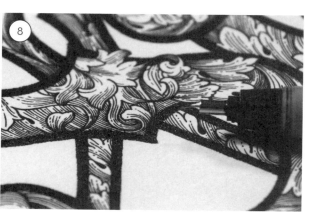

Don't worry about the numerous small white gaps in the border. These actually help give a natural, old-fashioned, bumpy texture to the artwork.

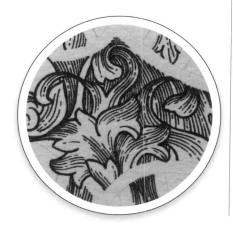

TEN OUTLINE PROJECTS

"INITIALS"

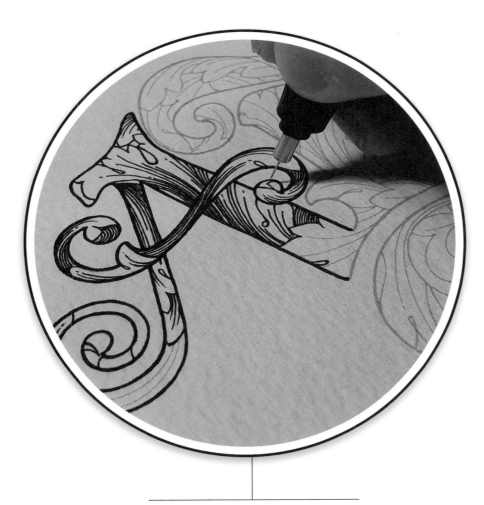

Bold outline contrasts with thin strokes and gives letters a more outstanding appearance, especially useful for logo design.

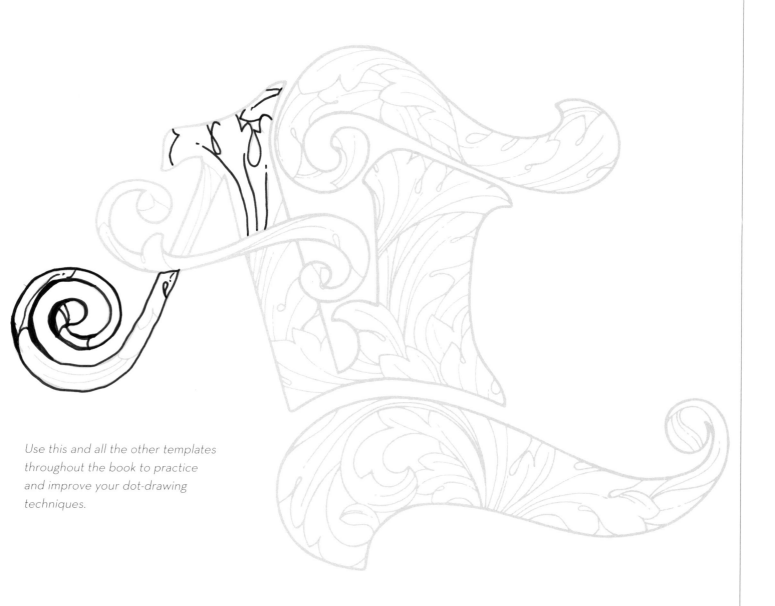

Use this and all the other templates
throughout the book to practice
and improve your dot-drawing
techniques.

"INITIALS"
Template and outline

"ZERO"

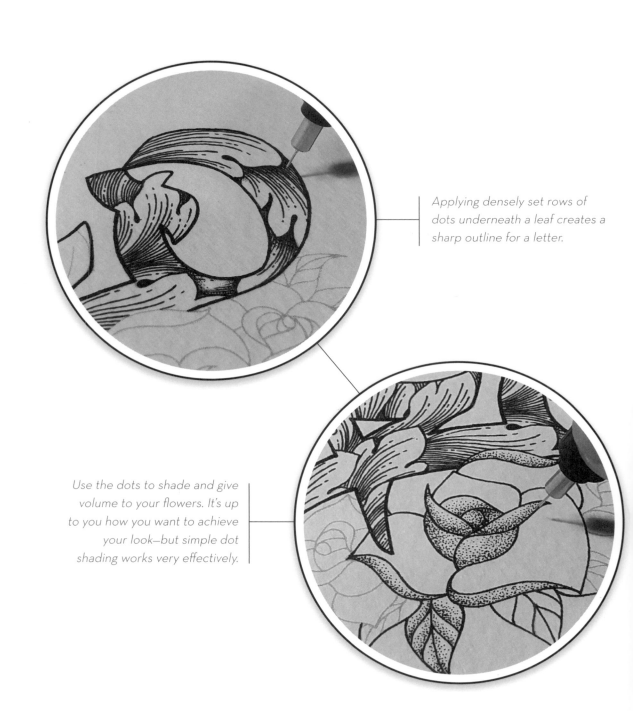

Applying densely set rows of dots underneath a leaf creates a sharp outline for a letter.

Use the dots to shade and give volume to your flowers. It's up to you how you want to achieve your look—but simple dot shading works very effectively.

"ZERO"
Template and outline

"ART"

Detail of the letter *T*. Bold outlines around the leaves pull them out from the thin strokes of the background. Be playful with your lines by drawing them at different lengths. Don't worry about the effect; the more creativity you put in, the more distinctive and individual your style will become.

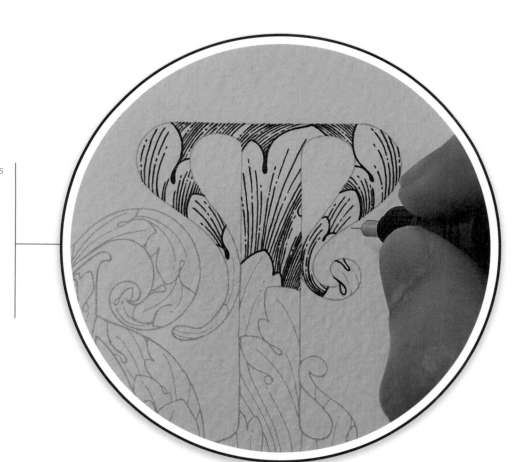

"ART"
Template and outline

"BRAVE"

The greater the number of inner lines in the background, the better the letters pop out. However, be careful not to overdo it by drawing too many lines.

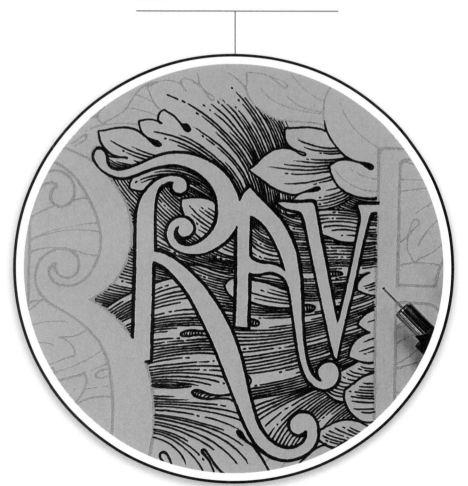

"BRAVE"
Template and outline

LETTER C

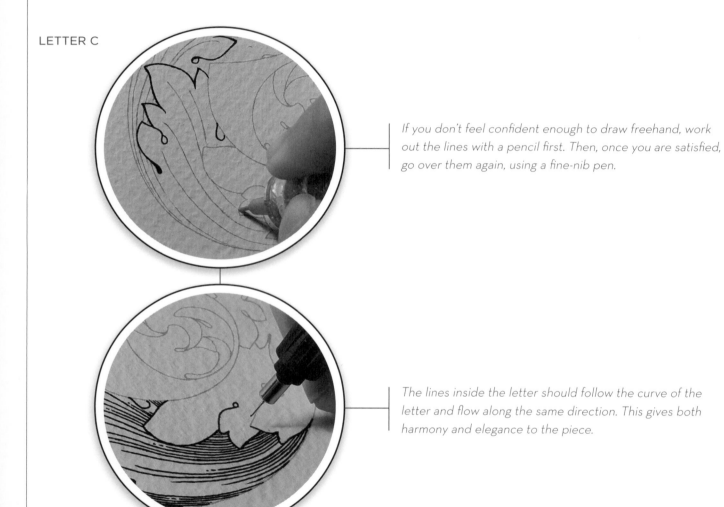

If you don't feel confident enough to draw freehand, work out the lines with a pencil first. Then, once you are satisfied, go over them again, using a fine-nib pen.

The lines inside the letter should follow the curve of the letter and flow along the same direction. This gives both harmony and elegance to the piece.

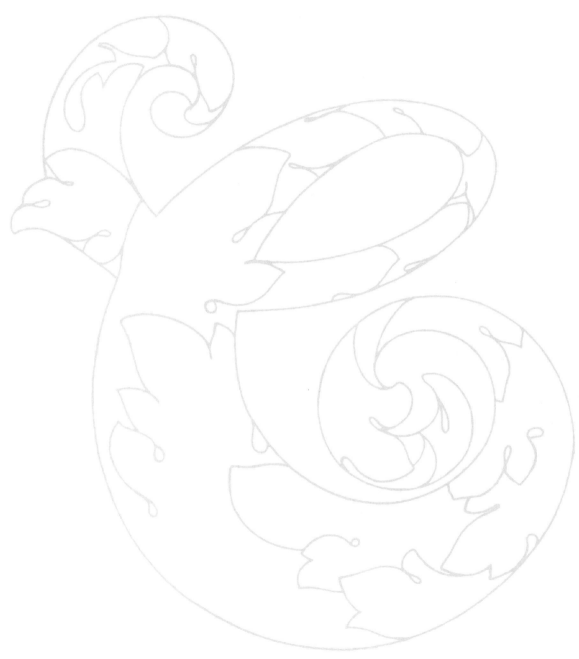

LETTER C
Template and outline

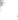

"HOPE"

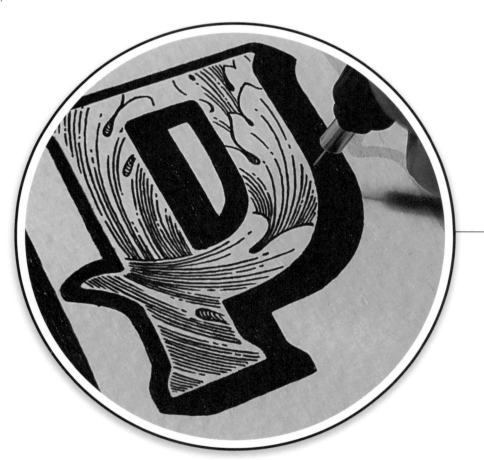

This time the letterforms are much squarer with heavy, blocky outlines. Fill the gray area with black ink rather than dots. The effect is simple and quicker than dot drawing but achieves much the same effect.

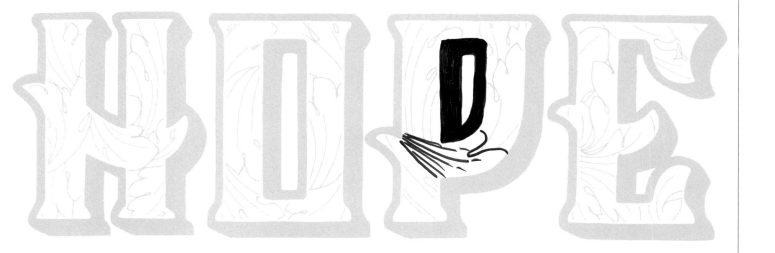

"HOPE"
Template and outline

"LOVED"

Detailing the letter L. After completing the foliate details of the interior, finish with dot drawing on the gray areas to provide greater texture to the project.

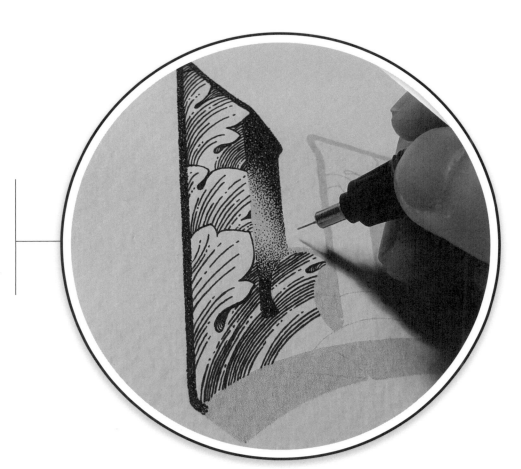

"LOVED"
Template and outline

ORNAMENTING LETTERS

Monograms are all about designing letters into a form that is
uniquely beautiful. They are especially striking when used as
a logo design or as personal insignia. I like to incorporate old-
fashioned decorative elements found in baroque, rococo, and
Old English ornamentation in juxtaposition with modern letters.
It is hard to go wrong using beautiful curved leaf shapes folded
inside the volumes. My best advice is to draw your letters with
bold, curved outlines, keeping the black lines sharp and clean.

LETTER M
Template and outline

"EMBELLISHED A"
Template and outline

"SIDE-BY-SIDE 69"
Template and outline

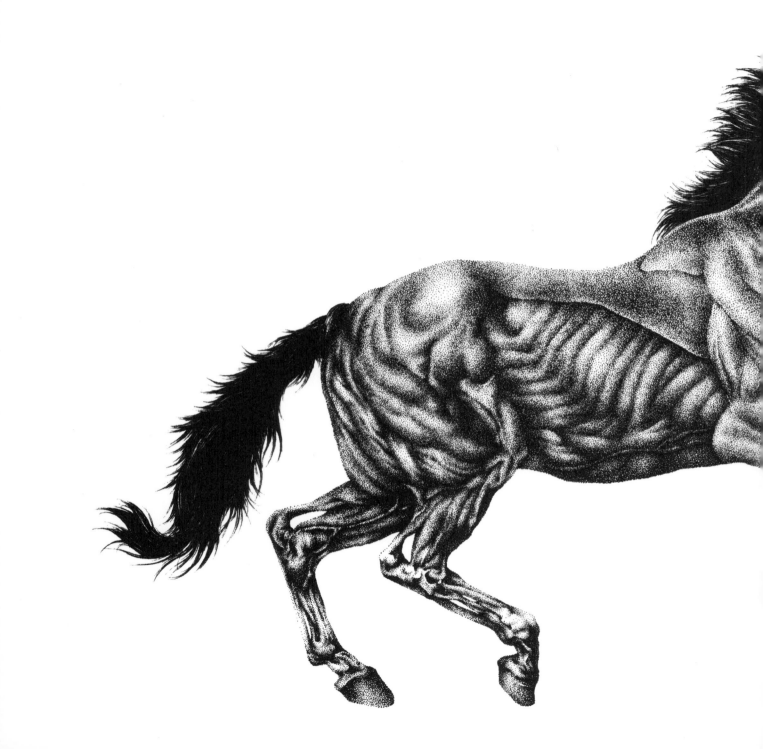

NATURE

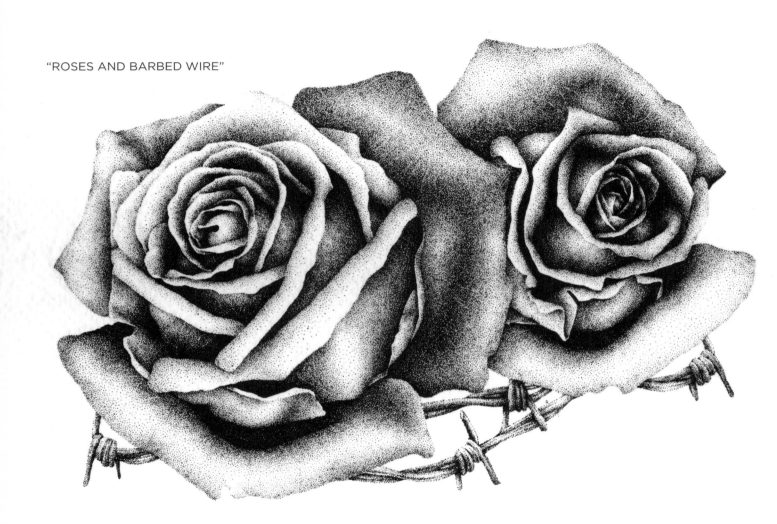

"ROSES AND BARBED WIRE"

ROSES AND BARBED WIRE

The earliest illustrations are often associated with scientific advances, especially biological and botanical discoveries. This was of course in the days long before photography, when an illustrated record of the subject required accurate scientific detail. Accordingly, scientists hired artists to draw their newly discovered plant and animal species. For greater detail, artists used watercolor to accurately record precise details and colors; these works would later be published in books, or as limited-edition prints and other works of art.

For many years I have used flowers in my pieces, often juxtaposed with a human skull. My intention is to convey the concept of life and death, and also the beauty of the afterlife. For me, nature represents life; meanwhile, natural decay—namely, the skull—symbolizes the afterlife. My concept of this has changed little over the years, and its roots still remain an important element of my work. One minor change I've made is to replace death with an inert object—particularly geometric shapes, since they are obviously nonliving subjects that nevertheless exist in nature. For example, imagine a beautiful bouquet of peonies contrasted against a centrally placed, gigantic, boldly outlined triangle. The highly detailed and fragile peonies balance beautifully against the rigid triangle. No matter what it is incorporated with, nature will find a way to unify the differences.

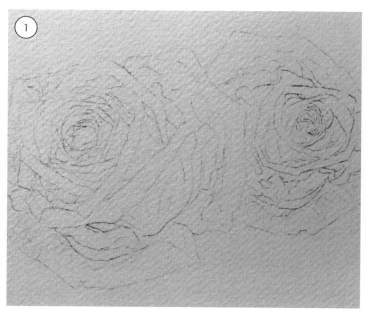

Compose both roses near each other, but tilted slightly to face different ways. The rose positioned in front appears slightly larger because it is slightly closer to your point of view.

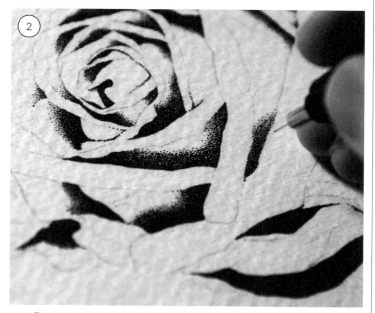

Focus on the darkest parts (also known as the shadow parts) first. Fill those areas with small black dots—the closer the dots, the darker the area.

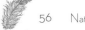

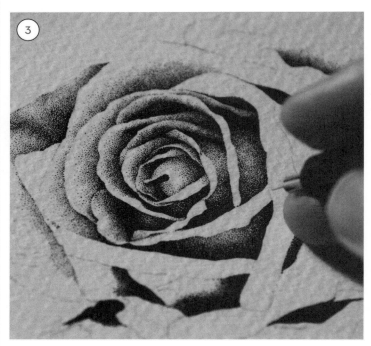

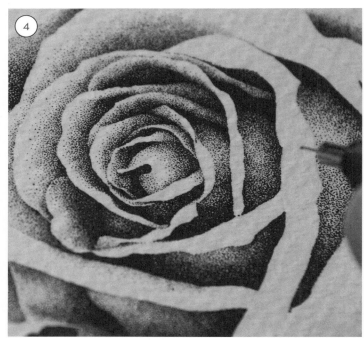

Make the dots densest at the edges where they meet the highlight areas. As when shading with a charcoal pencil, different spaces between the dots give different gray tones.

Use a pencil to mark out the areas for dark or light shading to guide you when you start dot drawing. Your aim is to achieve a realistic effect. Stipple one petal at a time so you can focus on each reflective area individually—every petal layer reflects light differently, so work accordingly.

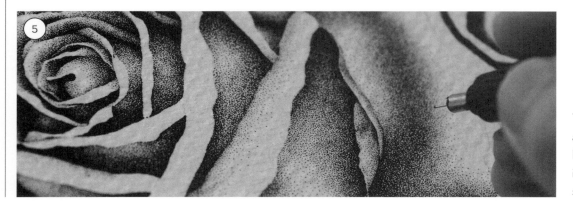

The edges of the rose petals are the brightest parts, so leave them clean. Stippling is required only where the shadows naturally fall.

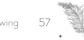

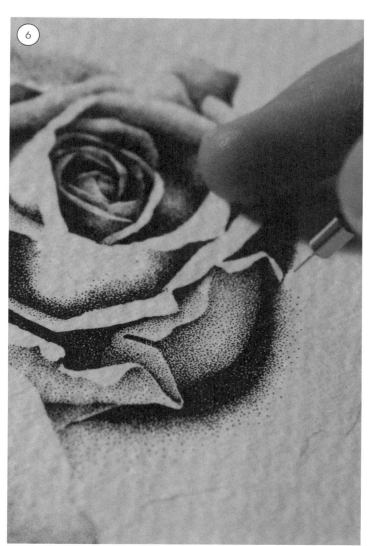

Move on to the second rose, using the same approach. The distance of this behind the front rose determines the overall amount of shade across the flower as a whole.

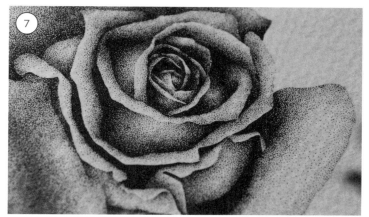

Stipple underneath the folded petal edges to emulate shadow, and define the shape and volume of the flower.

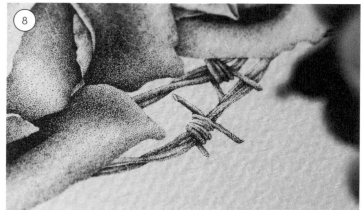

Barbed wire is made with thin steel and has a distinctly different texture to a rose. The wire reflects light mostly along its central axis—this looks like a single white line running along its length. Fill all details, using light and shade as necessary. Finished.

TEN OUTLINE PROJECTS

"SOLITARY ROSE"

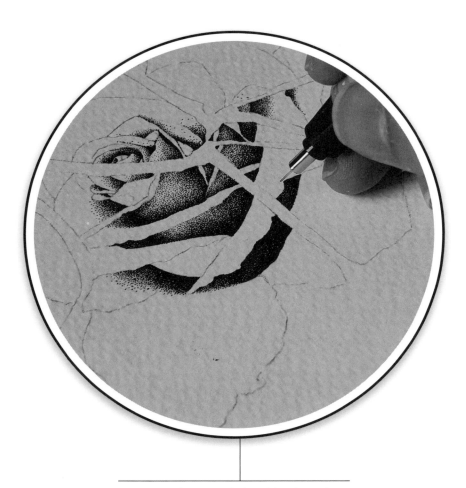

It's easy to be overwhelmed by the task ahead. So work on one small portion at a time. Start by filling the core shadow areas, then move on to cover the gray midtone sections with slightly fewer dots, leaving clear the highlight areas.

"SOLITARY ROSE"
Template and outline

"KNIGHT MOVE"

There are many and various ways
to portray hair; here I'm working on
a chess piece—the knight. This time
it is unnecessary to put in a lot of
detail, so I have drawn just dotted
lines to replicate the energy of a
horse's rippling mane.

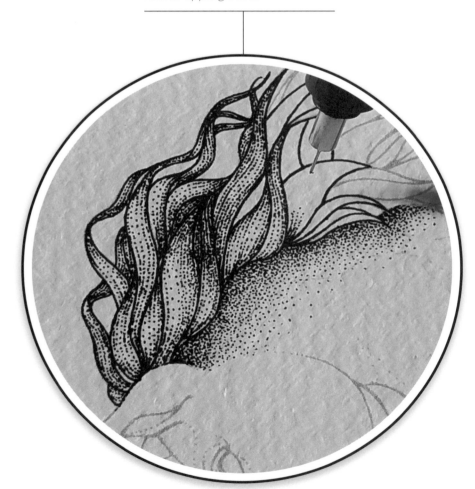

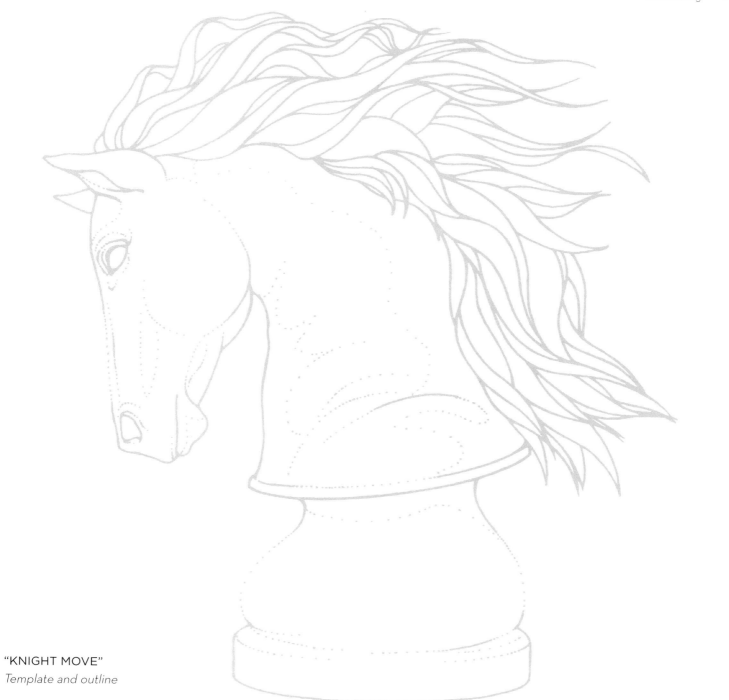

"KNIGHT MOVE"
Template and outline

"ELEPHANT AHEAD"

An elephant's skin is far from smooth, so I have drawn dots on uneven, wriggling crease lines at the top of the trunk and then spread the dots out into smoother lines as they move across the more even skin of the cheeks.

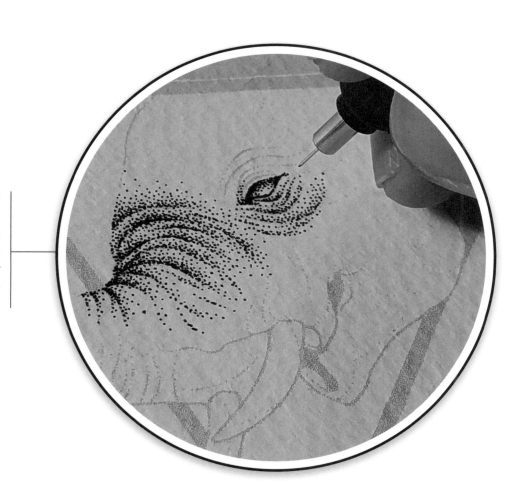

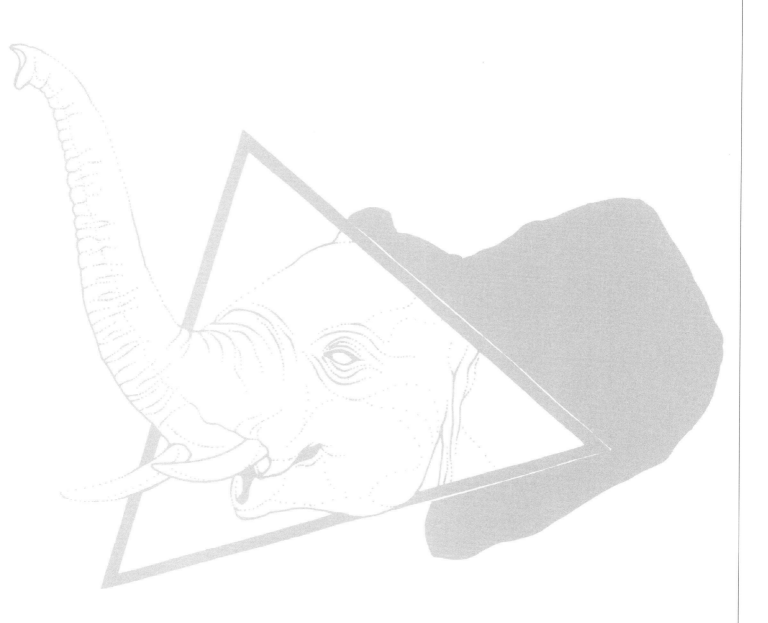

"ELEPHANT AHEAD"
Template and outline

"CRYSTAL ROSE"

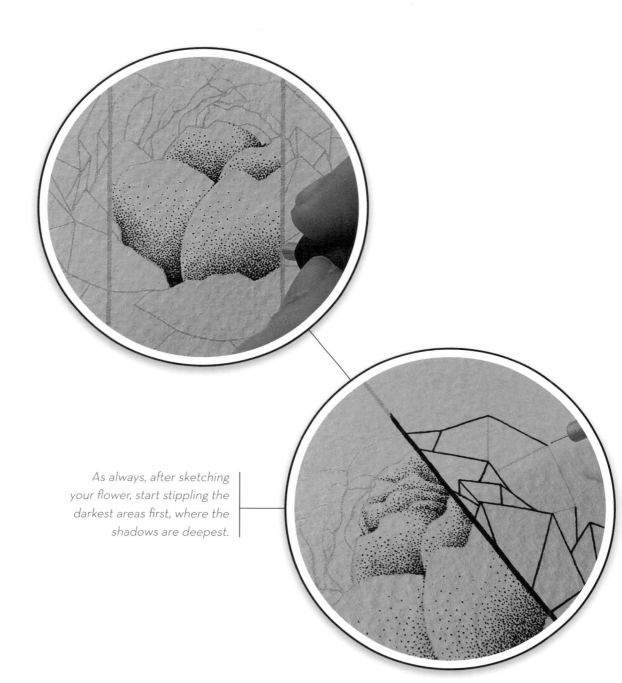

As always, after sketching your flower, start stippling the darkest areas first, where the shadows are deepest.

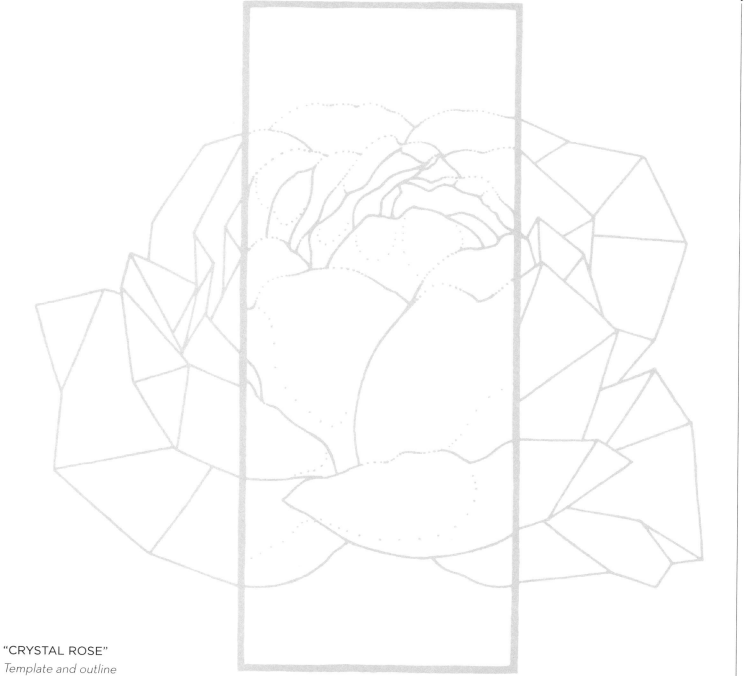

"CRYSTAL ROSE"
Template and outline

"EGYPTIAN DREAMING"

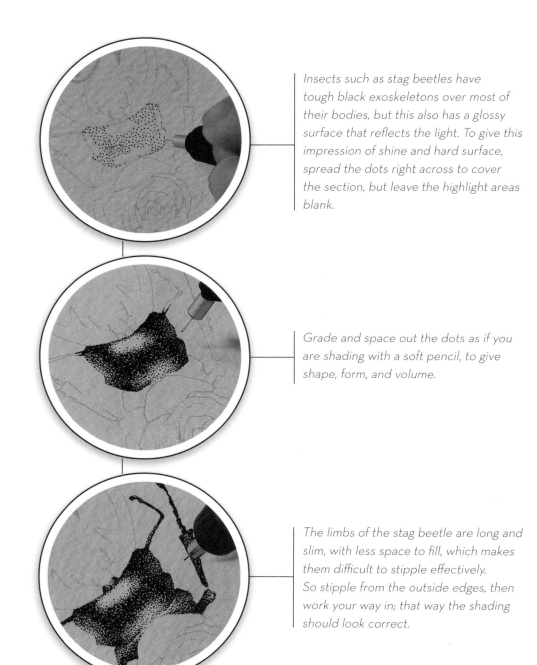

Insects such as stag beetles have tough black exoskeletons over most of their bodies, but this also has a glossy surface that reflects the light. To give this impression of shine and hard surface, spread the dots right across to cover the section, but leave the highlight areas blank.

Grade and space out the dots as if you are shading with a soft pencil, to give shape, form, and volume.

The limbs of the stag beetle are long and slim, with less space to fill, which makes them difficult to stipple effectively. So stipple from the outside edges, then work your way in; that way the shading should look correct.

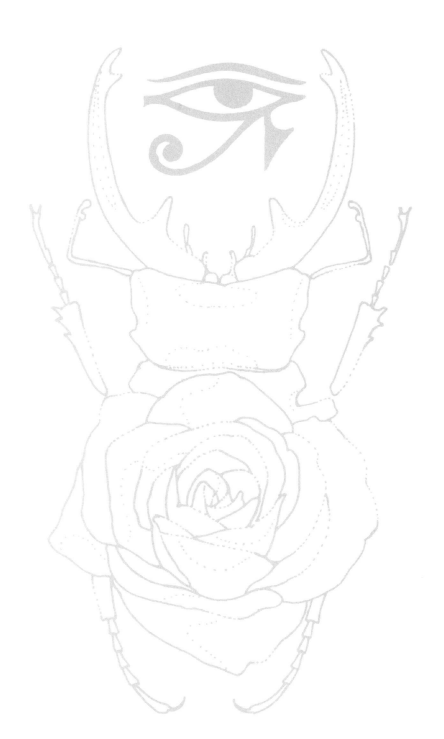

"EGYPTIAN DREAMING"
Template and outline

"A PEONY FOR OUR TIMES"

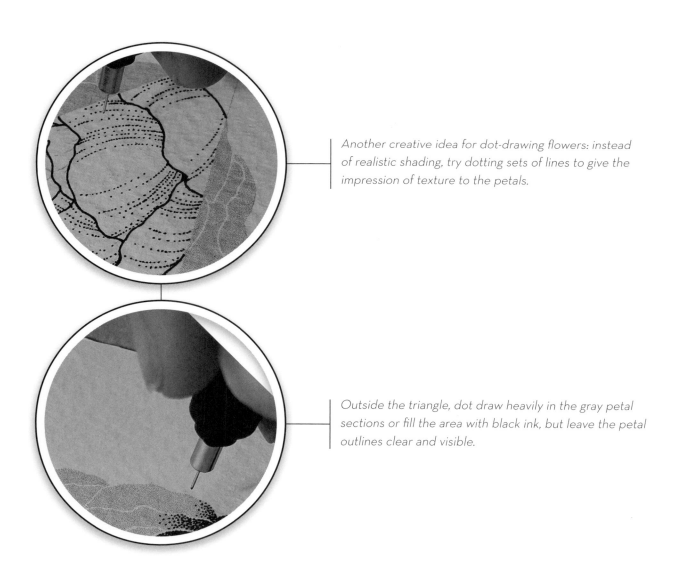

Another creative idea for dot-drawing flowers: instead of realistic shading, try dotting sets of lines to give the impression of texture to the petals.

Outside the triangle, dot draw heavily in the gray petal sections or fill the area with black ink, but leave the petal outlines clear and visible.

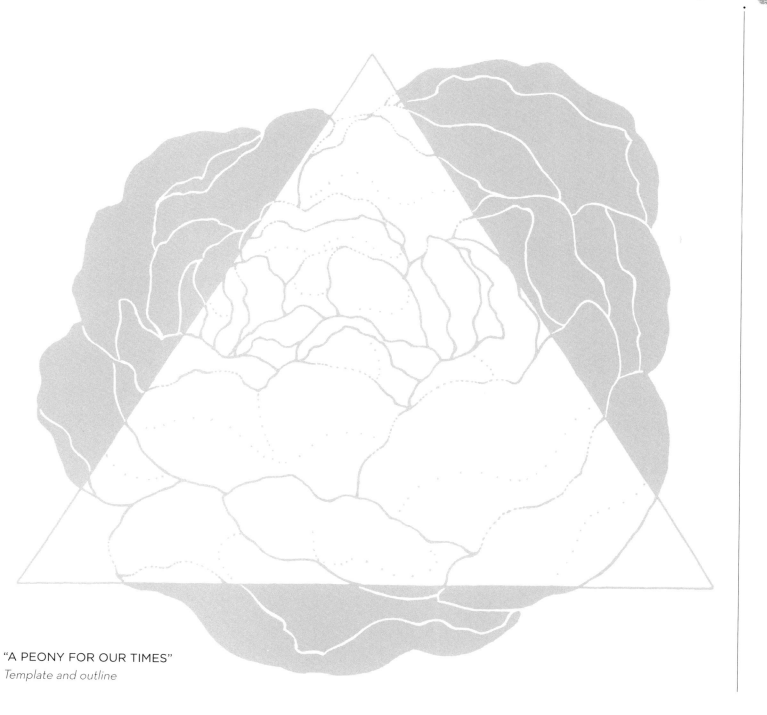

"A PEONY FOR OUR TIMES"
Template and outline

"ROSE MOON"

When stippling the interior of a specific shape or image, keep the dots strictly inside the outline.

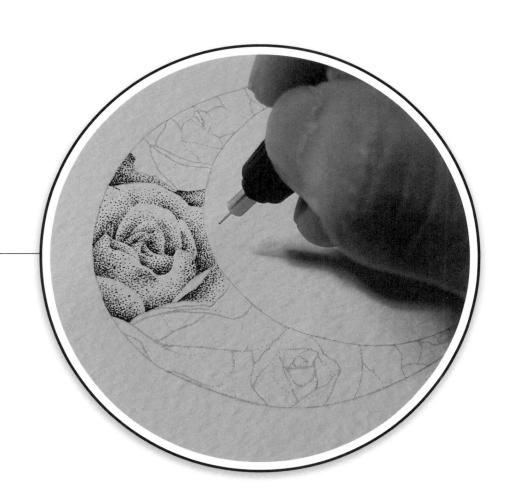

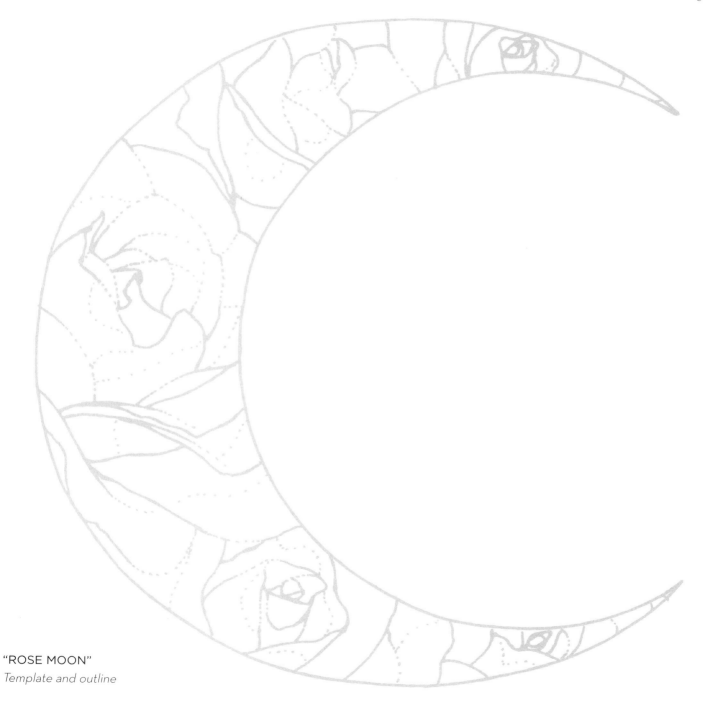

"ROSE MOON"
Template and outline

PROJECTS WITH A TWIST

My signature style tends to be full of heavily detailed, living objects that are then twisted in surprising and unusual ways. I especially like to combine realism/nature with strong geometric shapes and then soften the whole composition by rendering it in realistic dot drawing. I believe that it's these sharp contrasts that make my art individual and unique.

Before you start, decide on the objects that you want to draw, and research them in detail, so that, for example, you understand the structure of a stag skull, the form and function of rose petals, or the facial details of a male lion. Any research you do will help you achieve the accurate images you are after; then just let your imagination rip!

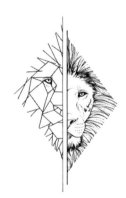 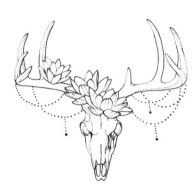 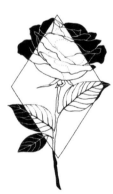

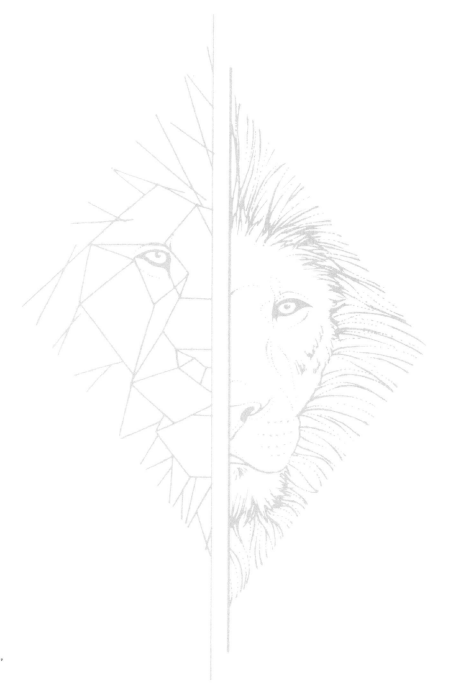

"SPLIT PERSONALITY"
Template and outline

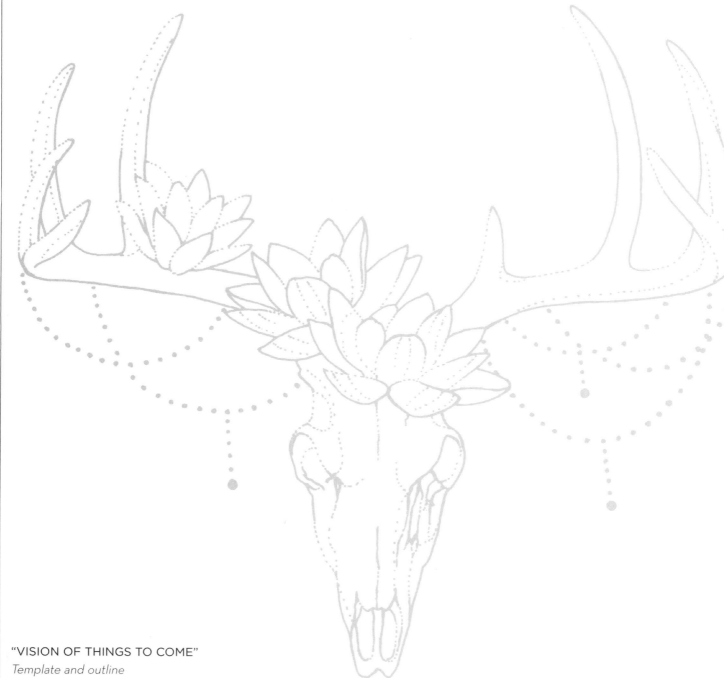

"VISION OF THINGS TO COME"
Template and outline

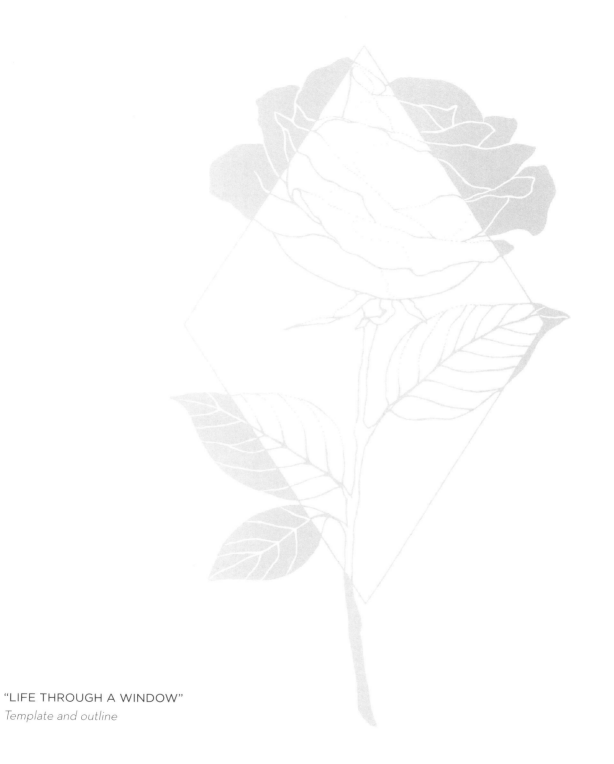

"LIFE THROUGH A WINDOW"
Template and outline

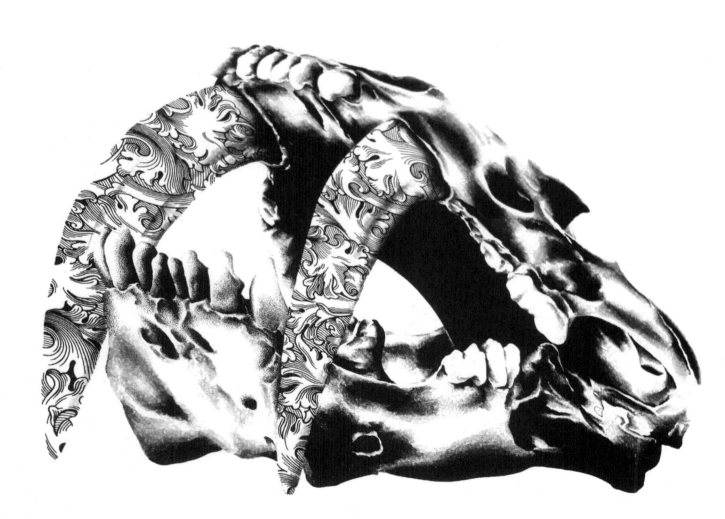

TATTOO

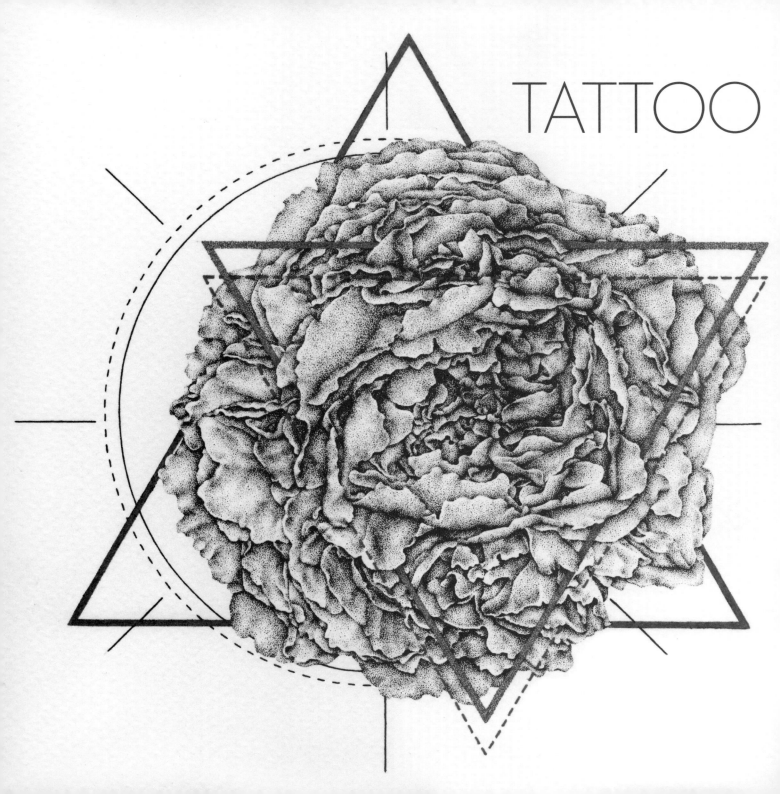

TATTOO

My first artistic passion was tattoo design. I consider that the human body is the perfect canvas for an artist to create a unique and magical image and then transfer it onto skin. For me it started as an ordinary, everyday life story where I searched for my first tattoo, but nothing caught my eye. Eventually I decided that the only answer was to develop my own tattoo style. Coincidentally, this was around the same time as I discovered dot drawing (or the stippling technique). I personally find that the complexity and detail of stippling provide a unique distinctiveness unlike any other technique, especially for a small tattoo. The more details that are included, the more realistic the work—this became my trademark. Besides dot drawing, I often incorporate other styles such as single-line drawing, to provide the contrast between maximal and minimal. Moreover, the beautifully complicated designs of Old English ornamentation are also a perfect combination—sometimes more is even better! It is undeniable that dotwork tattoo is currently a worldwide phenomenon, and it is so refreshing to see people are paying attention to the details of unique style, rather than just following common trends.

"ROSE TATTOO"

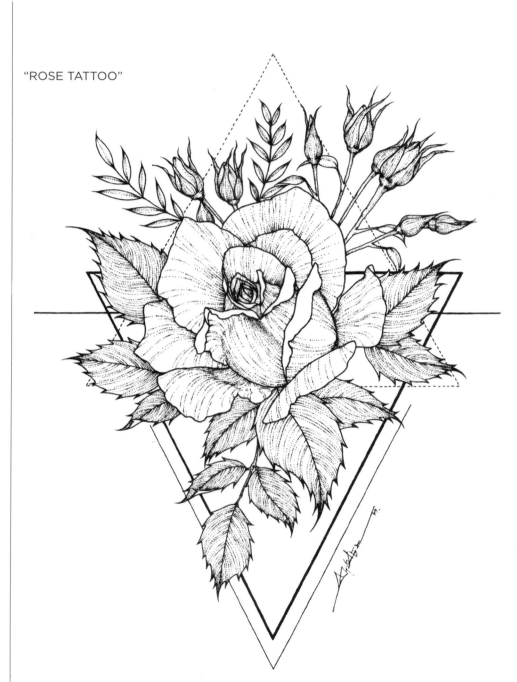

A tattoo is an artwork that is complete in and of itself, making the composition very important. It has to display its motifs creatively, to use simple ideas to draw everything together in a symmetrical image, but also feature small detail elements, or alternatively go bold with strong geometric outlines.

There are also different ways to create a dot-drawing tattoo. You can go for a realistic design or a simple dotted outline: my design style is halfway between. Dot-drawn tattoos are not necessary designed to be complex; you can minimize the number of dots by arranging them into a single line or mixing them together with dashes.

In the tattoo world, roses are eternally popular images, perhaps in part because they are so adaptable; anything from old-fashioned to modern minimal style, and everything in between.

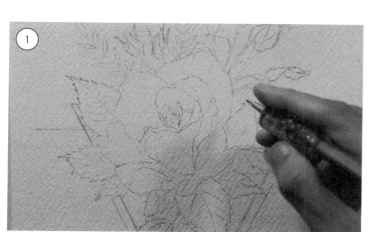

Every artwork starts with a simple sketch. In this case, gently pencil an idea of a dreamy bouquet of roses, composing each leaf cluster to support the centered rose.

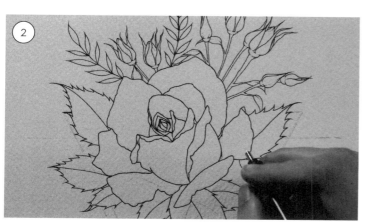

Finish the outlines with fine liner, keeping it clean and bold.

Geometric shapes help modernize an image, in this case to design a pattern of triangles underneath the bouquet.

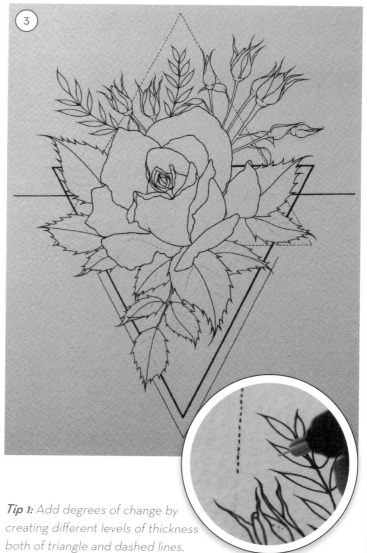

Tip 1: *Add degrees of change by creating different levels of thickness both of triangle and dashed lines.*

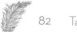

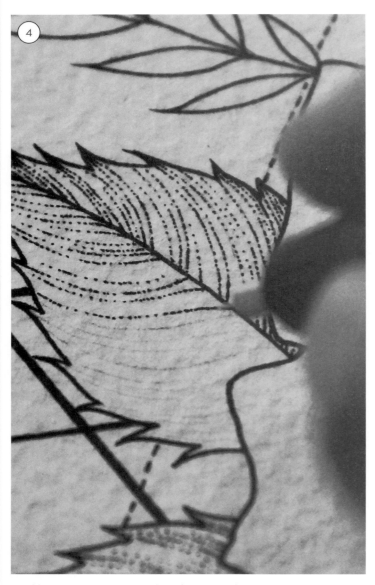

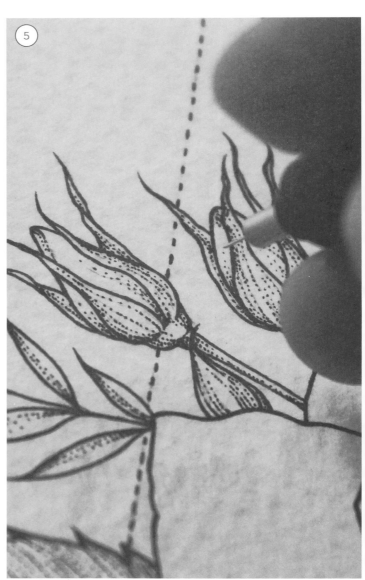

Real leaves are unique, and each species has its own variation of patterns. The simplest way to imitate this is by dotting in lines following their natural forms and flow.

Apply the same technique to decorate the rosebuds. Dot in lines, starting with the base of each bud, but do not overdo it; keep the amount of space between each line consistent.

Tip 2. Make the dotted lines on the rose petals flow with the shape to give a three-dimensional effect.

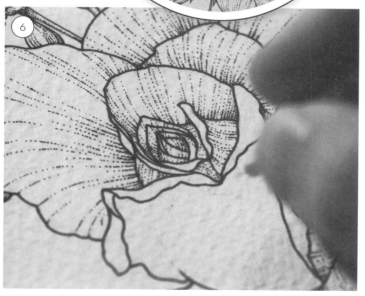

Finish all the little necessary details.

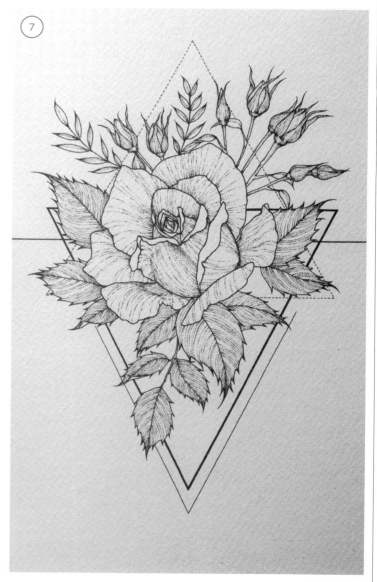

Do the same with a rose, petal by petal; allow yourself to be creative with patterns.

TEN OUTLINE PROJECTS

"MY PASSION"

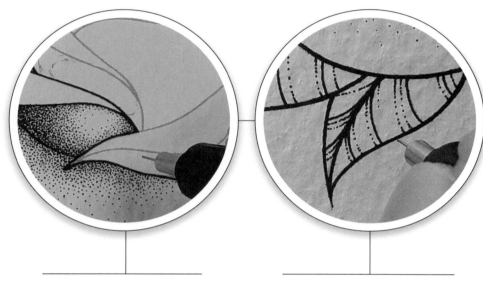

Thicken the outlines to create a frame within which to make your dot drawing. Grade the dots across the surface according to where the shadows land.

Leaves usually work as decorative elements in my designs. Lightly detailed leaves really help the artwork—try to mix dots with lines to create unique and interesting rhythms.

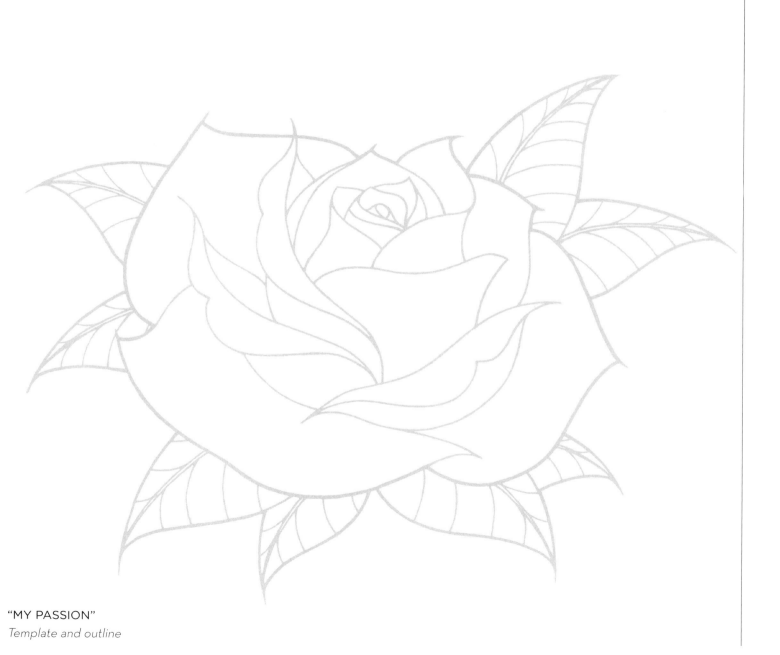

"MY PASSION"
Template and outline

"FEATHER"

To make a really elegant design, I used pure dotwork along the filaments of the feathers. This takes a long time to complete but is well worth it for the result.

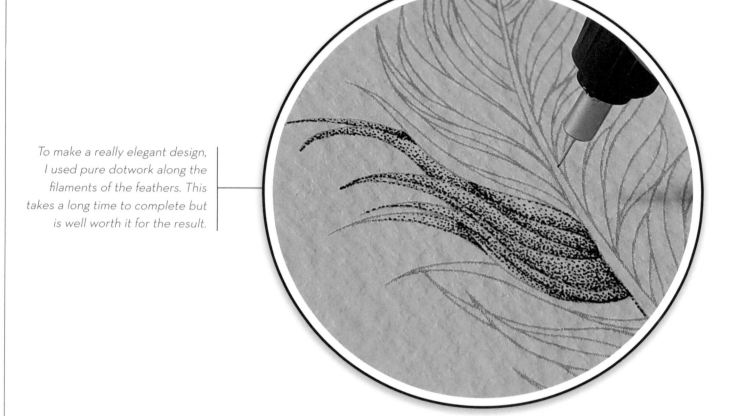

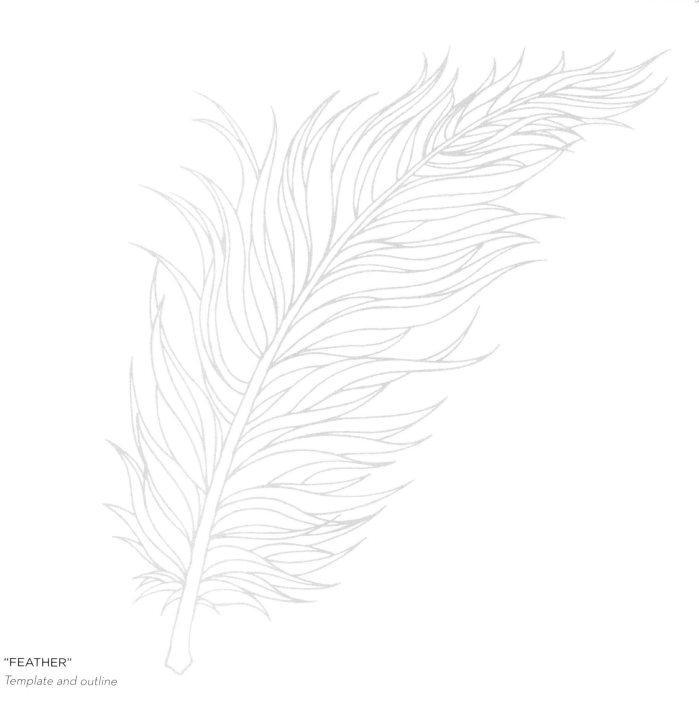

"FEATHER"
Template and outline

"SHADES OF THINGS TO COME"

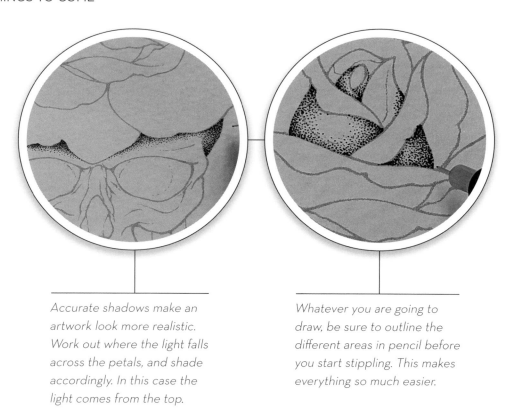

Accurate shadows make an artwork look more realistic. Work out where the light falls across the petals, and shade accordingly. In this case the light comes from the top.

Whatever you are going to draw, be sure to outline the different areas in pencil before you start stippling. This makes everything so much easier.

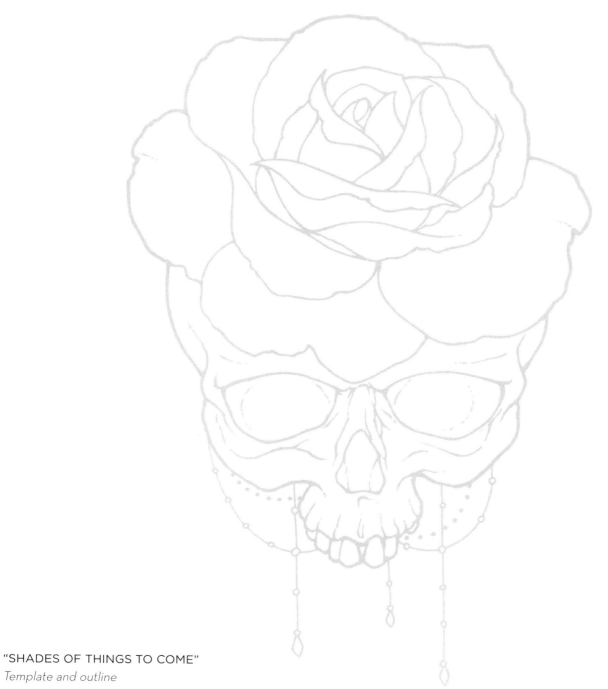

"SHADES OF THINGS TO COME"
Template and outline

"LOOK ON THE BRIGHT SIDE"

To get a crinkle effect, dot only along the gray lines and outline the disk florets. Don't flood the area with dots—you are trying to represent texture here, so work lightly.

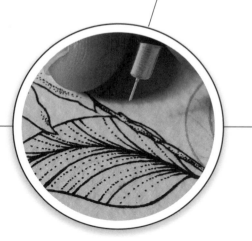

Dots in different quantities and densities but held within strong lines give each layer an individual and stunning look.

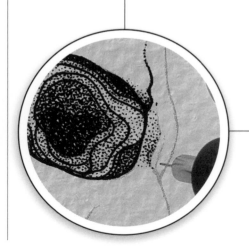

You can go with simple lines or a more complicated design like this by mixing up different elements.

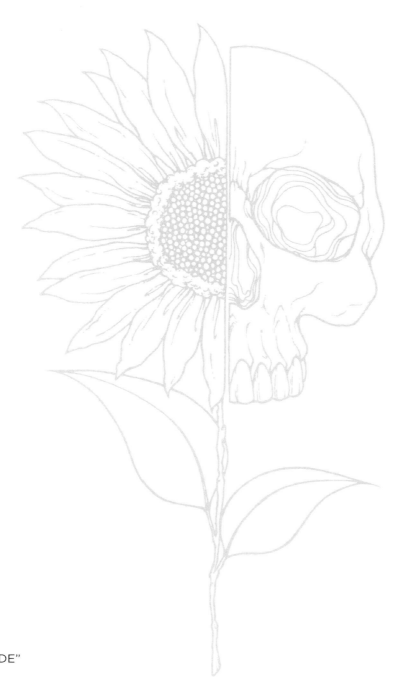

"LOOK ON THE BRIGHT SIDE"
Template and outline

"ORNAMENTAL KNIFE"

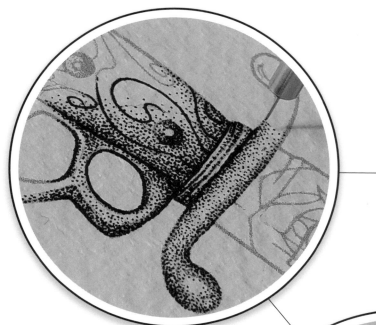

This knife contains a number of materials, so stipple each in a slightly different way to emphasize their difference. Make the dots on the wooden handle darker than the metal rings.

Leave the highlighted areas of the knife empty of dots to indicate reflected light. Dot draw on the blade itself so as to emphasize its convex surface, especially the thin curve at the point.

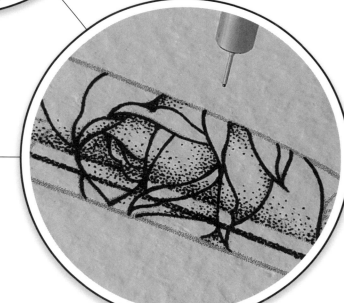

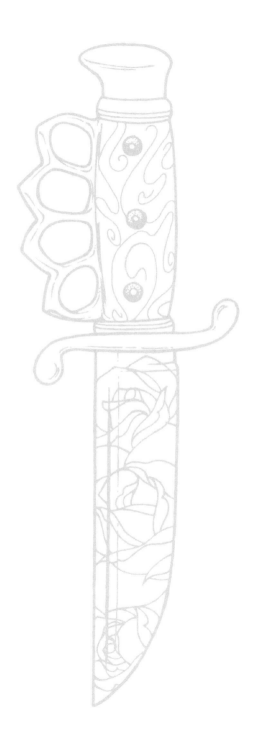

"ORNAMENTAL KNIFE"
Template and outline

"THE WORLD IS MY OYSTER"

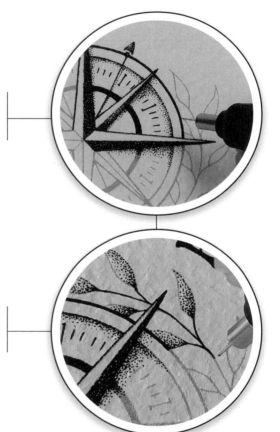

*The use of shadow is great technique to capture
an accurate design. Remember to choose your light
direction and work the shadows away from its source.*

*The small surrounding leaves soften the overall
design and provide contrast against the strong
black outlines of the compass.*

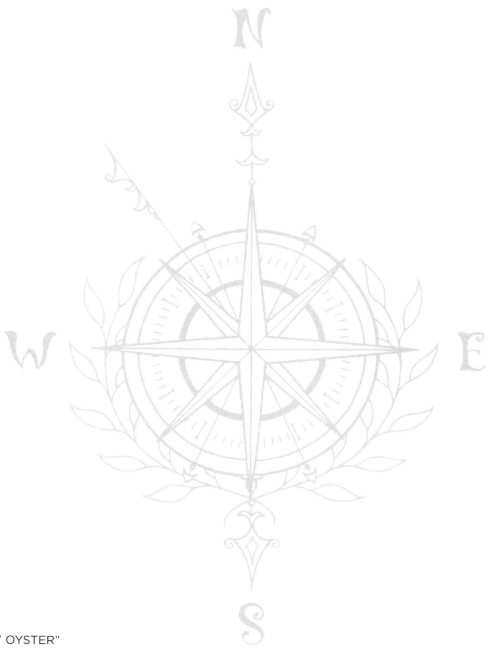

"THE WORLD IS MY OYSTER"
Template and outline

"CONSIDER THIS"

Depth is given to this piece by the varying thickness of the outlines, while the triangle draws our eyes to focus on what's inside.

Draw heavy black lines over the sketched outlines, then add sets of dotted lines to imitate the texture of each flower petal.

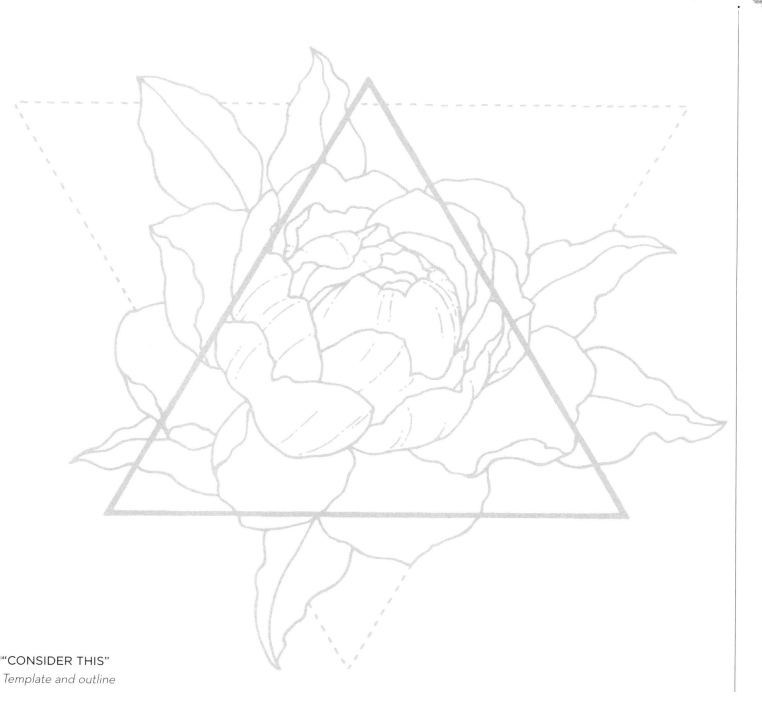

"CONSIDER THIS"
Template and outline

EXPLORE YOUR CREATIVITY

These next three projects are here for you to explore with various dot-drawing approaches. Remember, stippled tattoos do not require enormous detailing—indeed they are often better for being clear and precise. Try using some of the earlier-described techniques—for example, draw a line pattern of dots on the flowers while using dot-drawing shading techniques on the skull; alternatively, fill in the roses with black ink, leaving the outlines white. You could also incorporate dot lines on the owl feathers rather than stippling each feather one at a time.

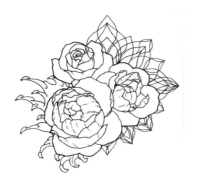
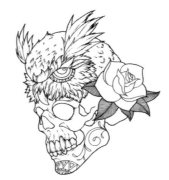
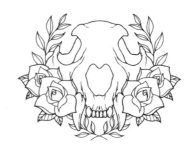

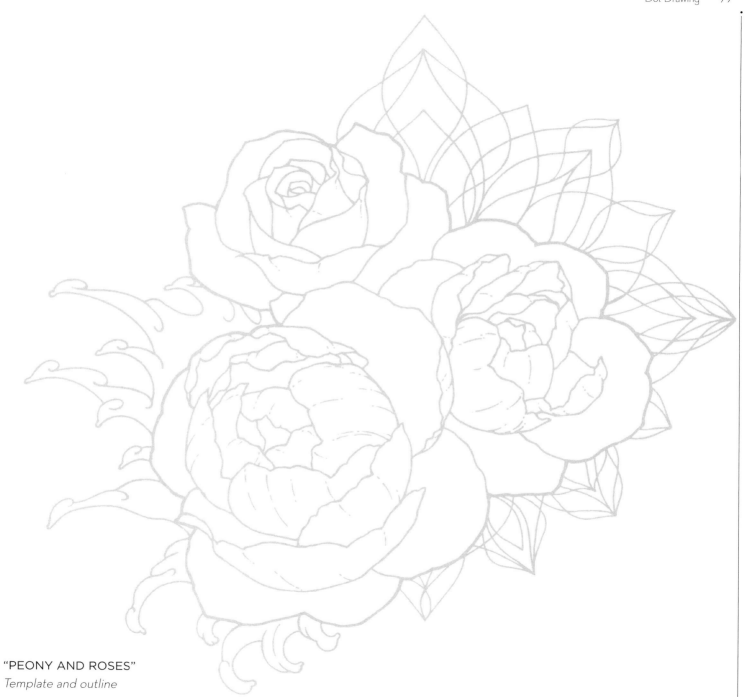

"PEONY AND ROSES"
Template and outline

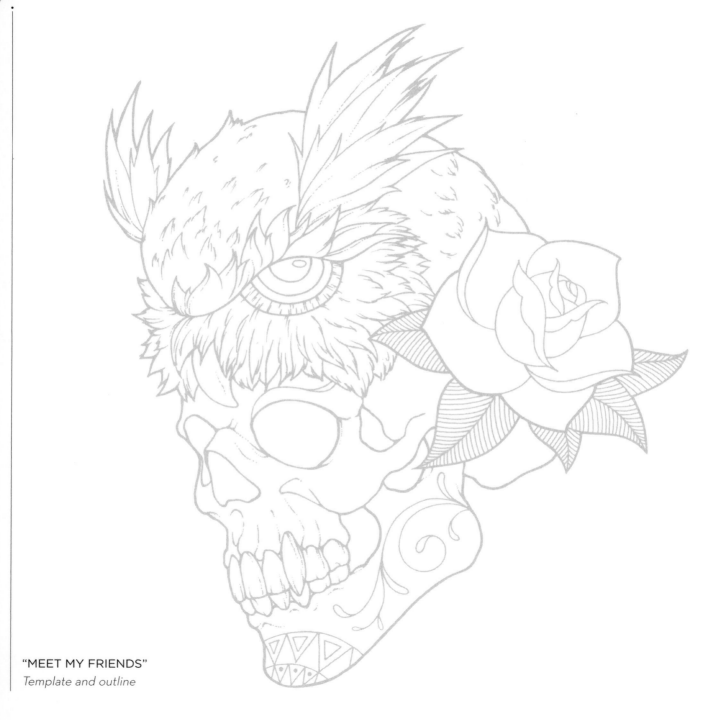

"MEET MY FRIENDS"
Template and outline

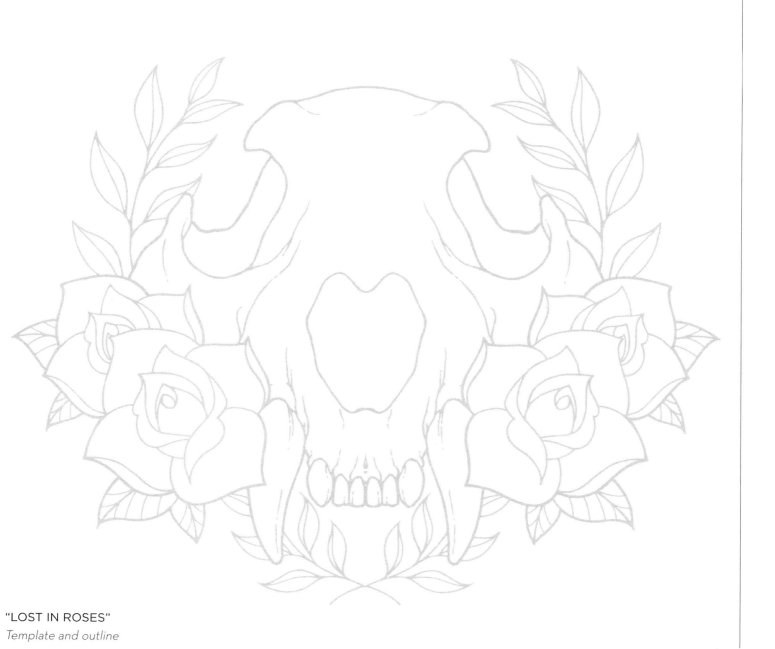

"LOST IN ROSES"
Template and outline

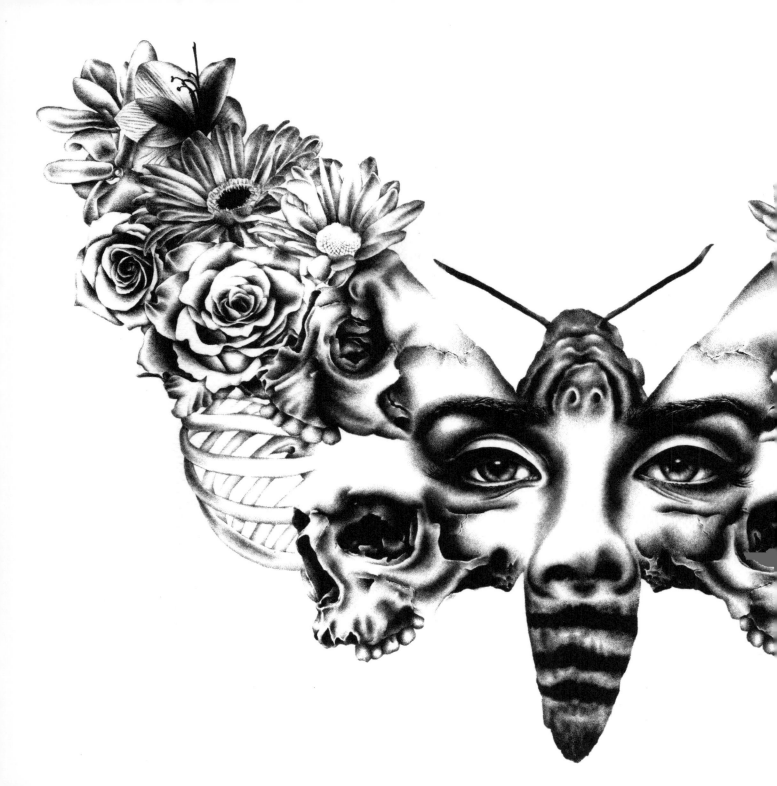

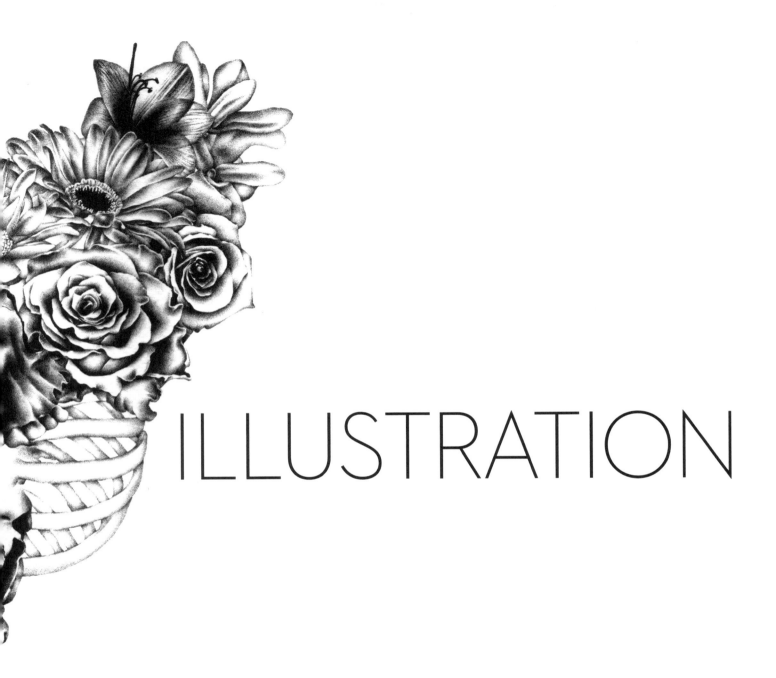

ILLUSTRATION

"ARRIVAL OF SPRING"

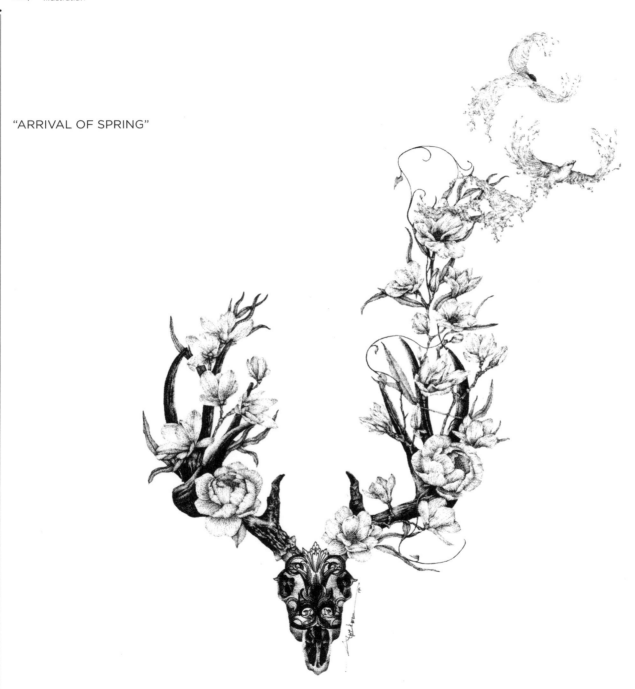

ILLUSTRATION

Illustration is an early form of artwork originally devised to convey information—a visual explanation of ideas, texts, and stories. For centuries, illustration has been closely associated with the publishing industry, especially during its so-called golden age in nineteenth-century Europe. The evidence is apparent in the newspapers and magazines of the 1800s, where delicately drawn illustrations developed alongside printing technology. Print suddenly offered illustrated and colored flowers, animals, and landscapes, and cartoons started to grow in popularity. Fast forward to the present day, and it is clear that illustration is one of the most practiced art forms worldwide.

In my early professional years, rather than just working with high-contrast stippling, I used black and different shades of gray brush pens to add extra depth to my artwork. But sometimes I found this created an awkward imbalance between light and dark. After I analyzed the problem, I changed to use only stippling to achieve consistent contrast between black and white.

My main artistic concept right from the start has been to explore the beauty of the afterlife. The composition of a skull surrounded with living flowers gives the perfect contrast between life and death. Most of my early drawings featured human skeletons or skulls, showing destruction and the afterlife, a theme I describe as my signature style. However, more recently, my style has slightly changed to become lighter; my subject matter now concerns courage, life, and my love of nature.

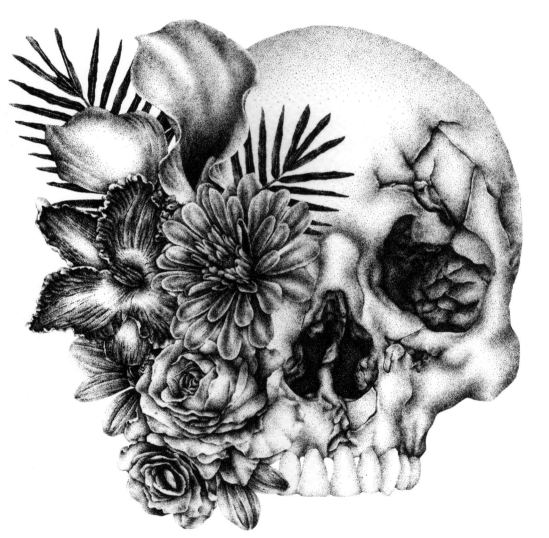

Illustration, in my opinion, is as much about interpreting ideas through drawing as for the beauty and skill of the work. Since ideas have no limitation, there can be an infinite range of imagination. However, the job of the illustrator is to translate these fantastic ideas into an understandable and coherent picture. For example, the concept for this particular work is that beauty flourishes from death. I transcribe this idea by using a skull to symbolize death and riotously blooming flowers to symbolize beauty.

"SKULL"

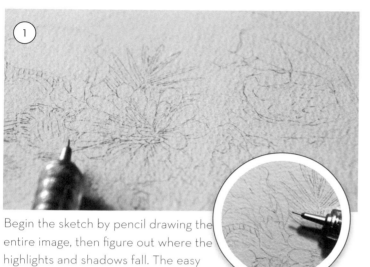

Begin the sketch by pencil drawing the entire image, then figure out where the highlights and shadows fall. The easy way to work out the dotting area is to map them out by drawing a simple line.

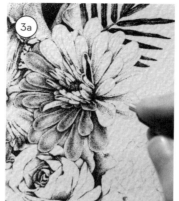
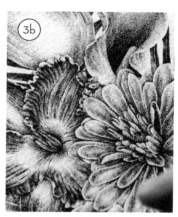

Imagine where the natural light will reflect on each petal, and dot draw to show the levels of darkest to brightest tones. Then add more dots with a fine-tipped pen to give the impression of three-dimensional images.

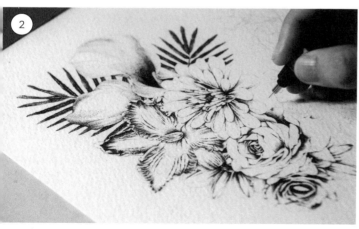

Carefully fill in the shadow areas with series of dots. Place the dots closely together to replicate shadow—most of these will fall around the edges. The more dots, the darker the area.

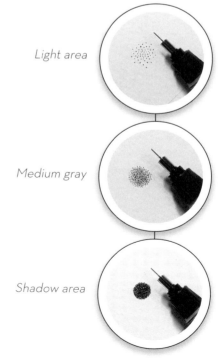

Light area

Medium gray

Shadow area

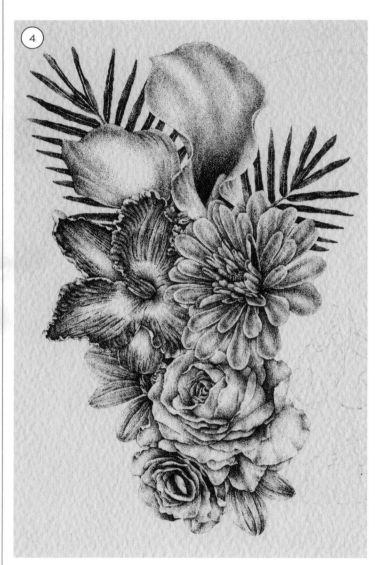

Keep in mind that flowers come in different colors, shapes, and forms. So, to avoid your drawing looking flat, plan ahead which flowers need more dots, and which need lighter tones.

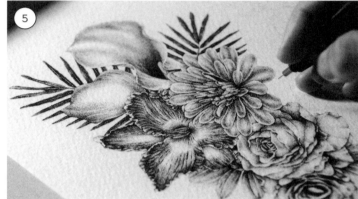

Finish any last details that have been missed.

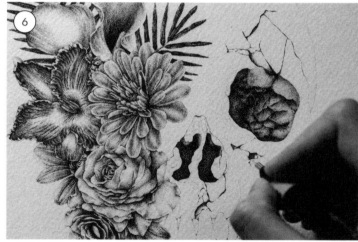

Now the skull. Use dense dots to fill in the eye sockets, and slightly fewer dots on the shallow interior surface. Do the same with the insides of the nostril holes.

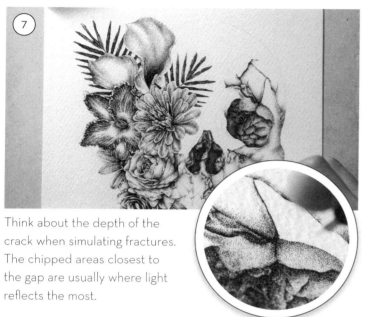

Think about the depth of the crack when simulating fractures. The chipped areas closest to the gap are usually where light reflects the most.

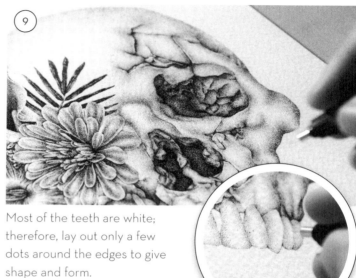

Most of the teeth are white; therefore, lay out only a few dots around the edges to give shape and form.

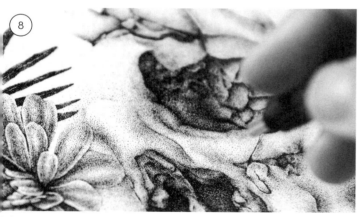

The amount and distance between dots will be the main factor in determining the depth and dimension of a drawing. For instance, the top strip of the nasal bone is brighter, while the surrounding areas are dimmer.

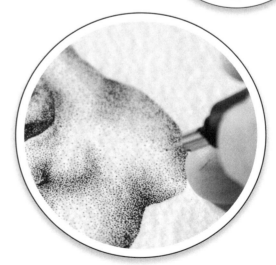

Tip: By spreading the dots farther apart you get the same effect as shading with a pencil.

TEN OUTLINE PROJECTS

"TIME PASSES"

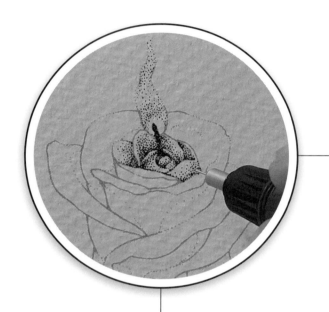

Inner-layer petals are small; therefore they are often shaded by the outer petals. So don't worry too much about the number of dots you put in; just keep the top section clean. Additionally, dot drawing a flame is tricky, so just leave a small, clear circle area around the wick, then shade the area around it.

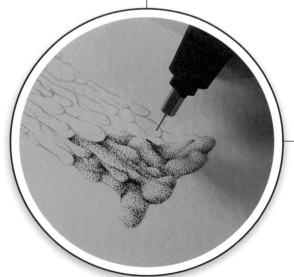

Melting wax has a unique rounded texture. Focus on the bulginess of dripping lines by stippling each line to have one side darker than the other.

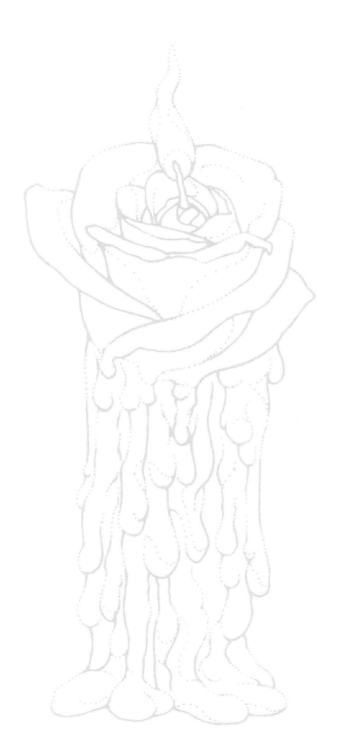

"TIME PASSES"
Template and outline

"FOREVER YOUNG"

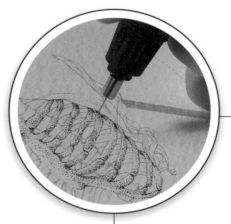

Highly detailed stippling is pretty much the only option when you draw human skeletons. To achieve the right effect, I suggest you dot draw one rib at a time and primarily focus on different levels of texture. Then replicate the shading on the next rib, and so on.

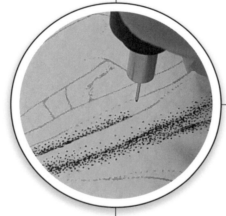

Fabric falls into wrinkles when it is worn: dot draw along the gray-penciled guide lines to provide texture.

You can either stipple to fill in the bold triangle outline or color it in with black ink—whichever you prefer; there is no right or wrong.

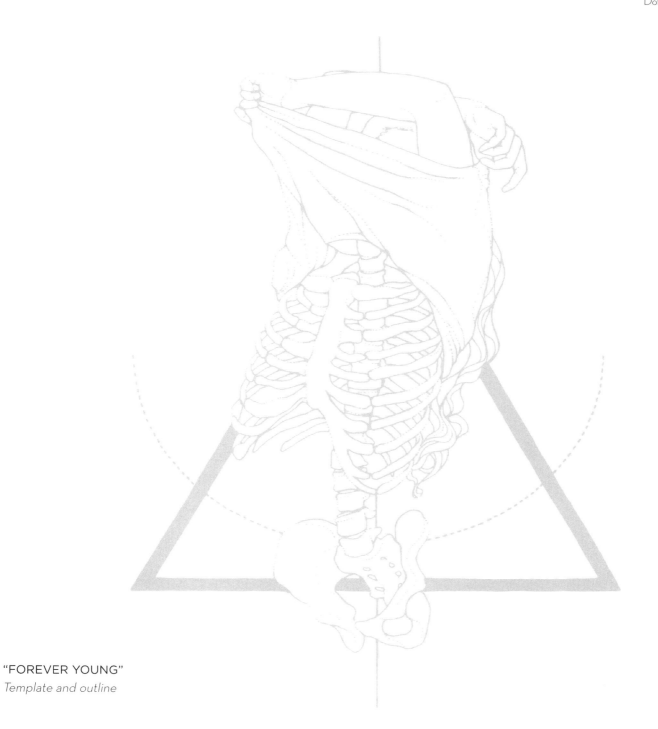

"FOREVER YOUNG"
Template and outline

"CROWNING GLORY"

Always start at the darkest section, in this case the eye socket area and interior of the nasal bone. Follow along the lines with dot drawing.

Fill up the gray area in the background with patterns of dots. When shading the midtone areas, remember that the skull and teeth are white—therefore, use far fewer dots than around the sockets.

Use the pencil line as your guide for placing the dots. Be careful about how many you put on the crown, and remember to alter the styling to indicate different materials.

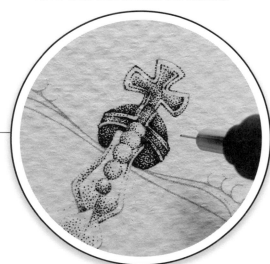

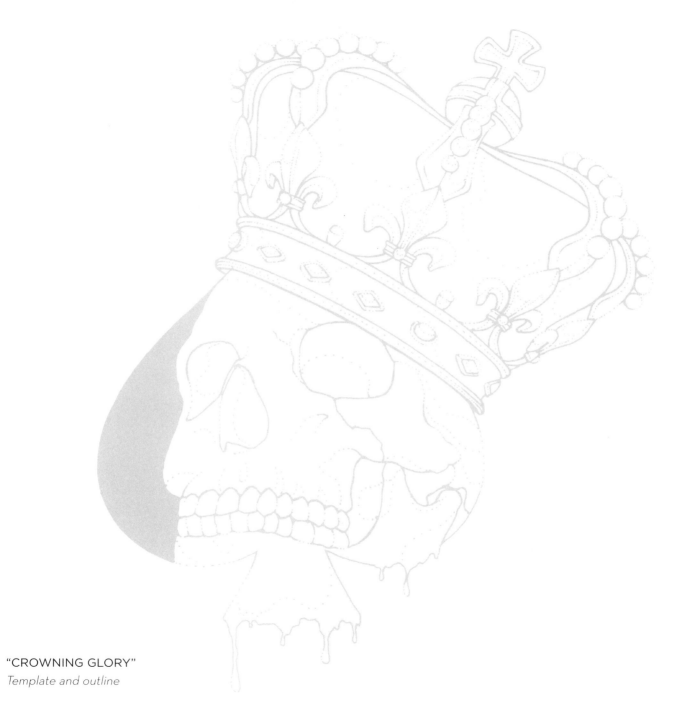

"CROWNING GLORY"
Template and outline

"HOPE"

Sets of dotted lines are simple yet effective for light texture on light-colored objects such as flowers, papers, etc.

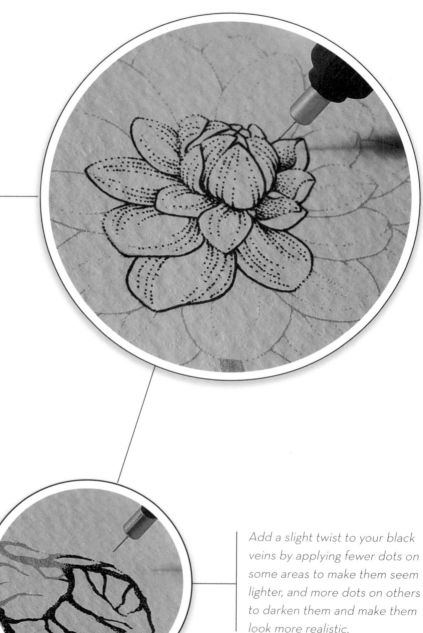

Add a slight twist to your black veins by applying fewer dots on some areas to make them seem lighter, and more dots on others to darken them and make them look more realistic.

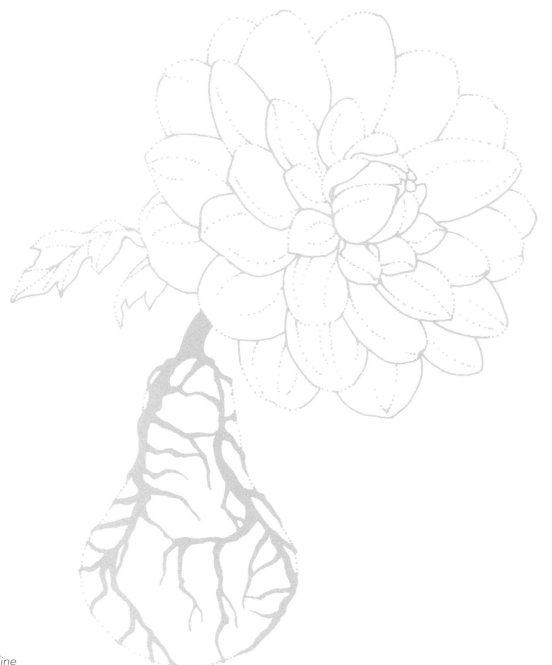

"HOPE"
Template and outline

"THE MUSIC OF LIFE"

Begin with the violin; this will help you figure out how to balance the dotted shading. Keep the bulge at the base clear and, for the moment, keep the gray area of the f-hole similarly clear. Stipple strictly within the gray lines.

Because the surface of a violin is not flat, but lightly curved, the light reflects differently across its surface. This needs to be represented in your shading levels so it that looks realistic.

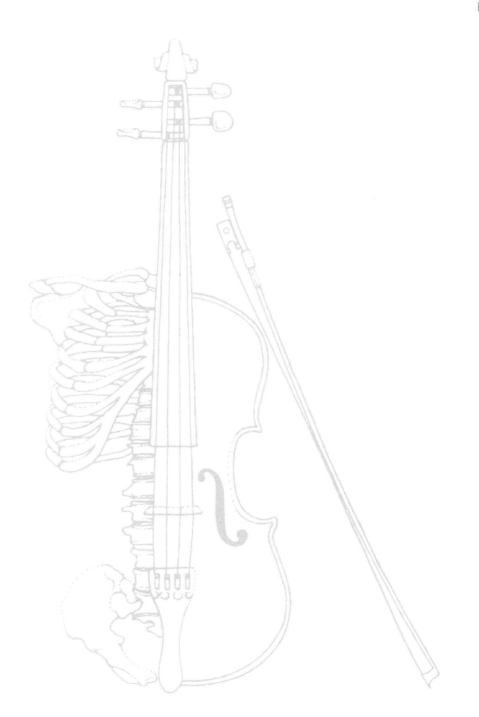

"THE MUSIC OF LIFE"
Template and outline

"KEY TO MY HEART"

A key is made of metal and has a shiny surface—a tip for getting this to look right is to start from the edge. Edges require most dots to give the object form, and fewer dots or none at all in the middle section, where most light reflects. However, sometimes if you leave the occasional small gap near the edges, it can provide the impression of depth.

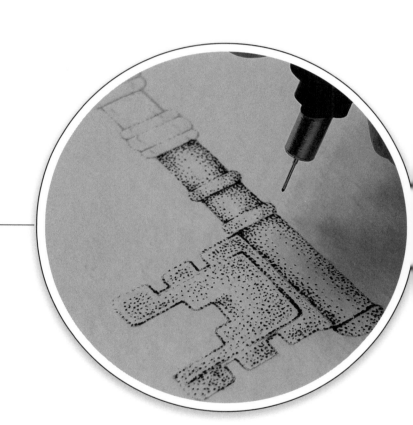

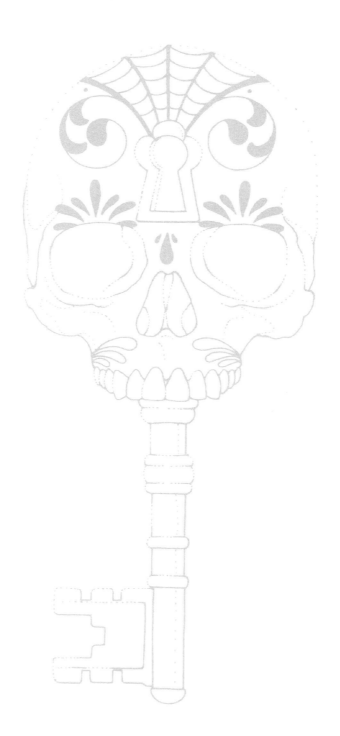

"KEY TO MY HEART"
Template and outline

"CRYSTAL CRANIUM"

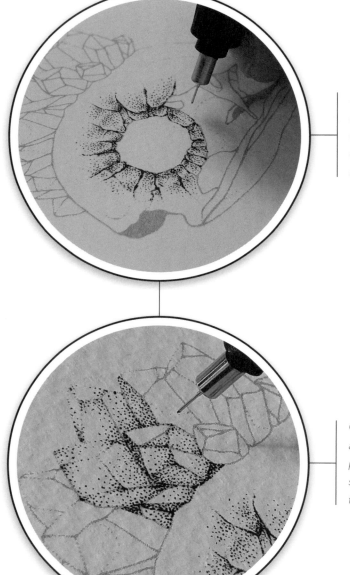

Different depths and heights are achieved by darkening the deepest cracks around the eyes; however, where there are no dots around the edges, the surface looks raised.

Crystals can be tricky because they are angular and sharp and reflect differing planes of light. Darken the edges and sharp corners by stippling mainly along the gray outlines.

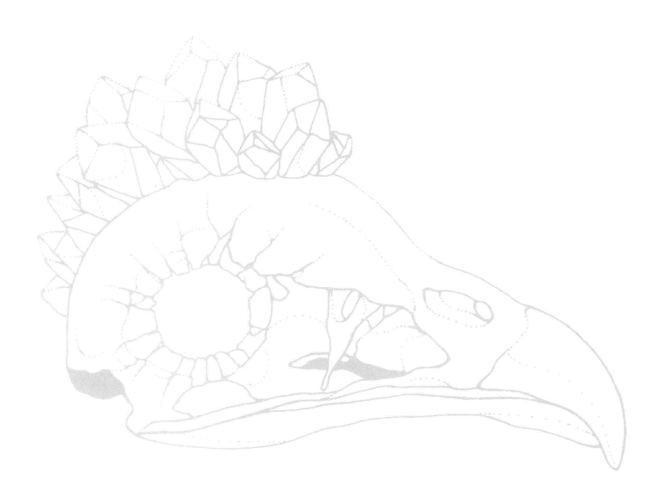

"CRYSTAL CRANIUM"
Template and outline

EXPLORE YOUR CREATIVITY

Stories can be told through images—these next three motifs tell
three different stories. As I have already mentioned, I regularly
draw skeletons and flowers together—the living and the dead.
The contrast of these two polar opposites is what I find most
interesting. The antique scissors were common illustrations
in vintage magazines, where they were used as a visual
representation of an idea to cut out and keep. I have chosen
them because they closely tally with my constant concept that
there is beauty after life.

 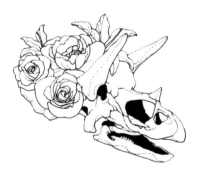 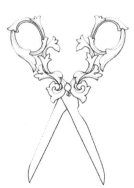

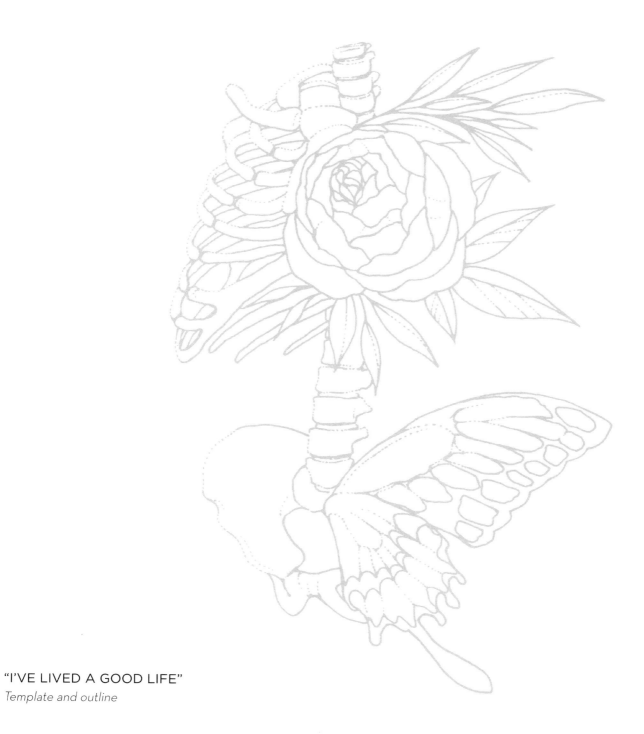

"I'VE LIVED A GOOD LIFE"
Template and outline

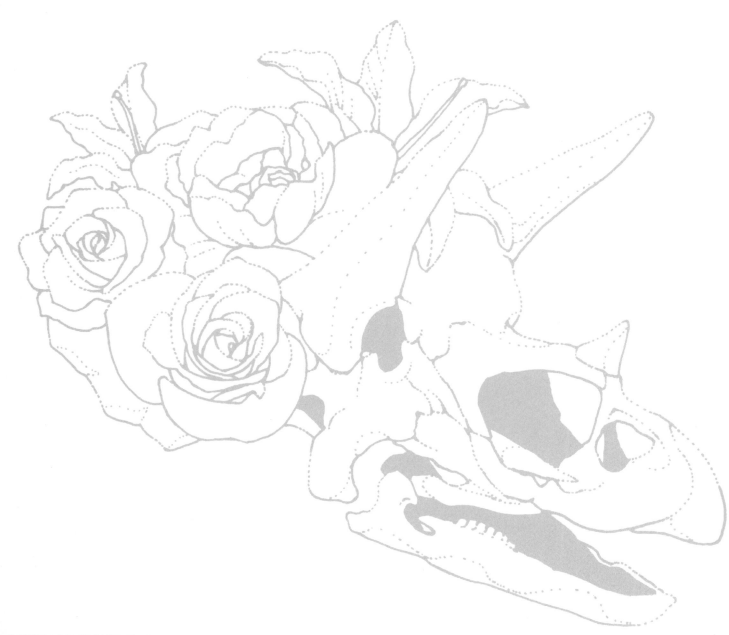

"MEET MY NEW FRIEND"

Template and outline

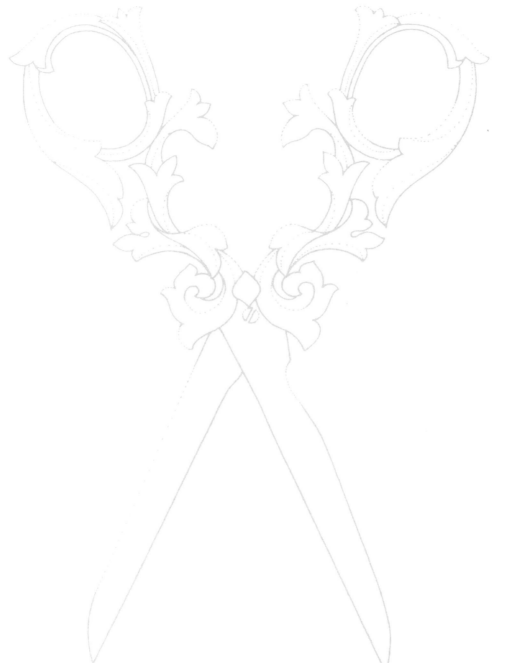

"SCISSORS"
Template and outline

ABOUT THE AUTHOR

Spider.Money specializes in creating graphic arts, illustration, book cover, and tattoo design for a wide range of clients. She was born and raised in Bangkok, Thailand. Although good at drawing, Spider didn't take the subject seriously until high school, when she became comfortable with her talent and began to embrace her skills. At Silpakorn University she majored in decorative arts and earned her degree in fashion design. As she searched for her own style and direction, dot drawing proved to be irresistible to her. In particular, its use of black and white emphasizes her work's constant theme of contrasts: dark/light, life/death, and so on. Spider's mantra is "Be honest to yourself; be authentic."

"Dot drawing is hugely challenging, but also massively comforting. Every single work requires enormous time and patience. But it's time well spent! When you realize who you really are, it shows in everything you do."